C O V E R
T O
C O V E R

Creative Techniques
for Making Beautiful Books,
Journals & Albums

Shereen LaPlantz

Lark Books

To Dorothy Swendeman,
who has filled this year with joyful book moments,
and to my husband, David, who greets all of my ideas
with the statement, "It sounds good; I think you should do it."

Published in 1995 by Lark Books
50 College Street
Asheville, North Carolina, U.S.A., 28801

© 1995 by Shereen LaPlantz

Design: Dana Irwin
Illustrations: Shereen LaPlantz
Production: Elaine Thompson, Dana Irwin

ISBN 0-937274-81-X

Library of Congress Cataloging in Publication Data
LaPlantz, Shereen, 1947-
 Cover to cover : creative techniques for making beautiful books,
 journals & albums / Shereen LaPlantz.
 p. cm.
 Includes bibliographical references and index.
 ISBN 0-937274-81-X
 1. Bookbinding. I. Title.
 Z271.L44 1995
 686.3--dc20 94-24439
 CIP

10 9 8 7 6 5 4 3

Printed in Hong Kong.

Lark ISBN 0-937274-81-X Casebound
 ISBN 0-937274-87-9 Paperbound

Contents

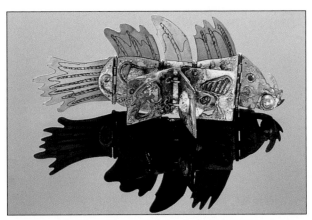

Fish Messages,
Judith Hoffman.

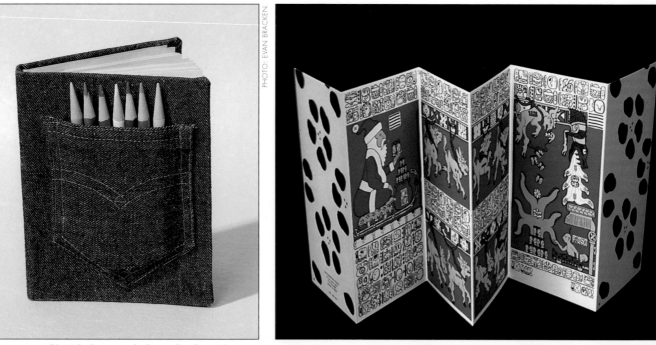

Untitled journal, Dorothy Swendeman.

Christmas card, Tom Jones.

Tea (in Honor of Friends), Elaine S. Benjamin.

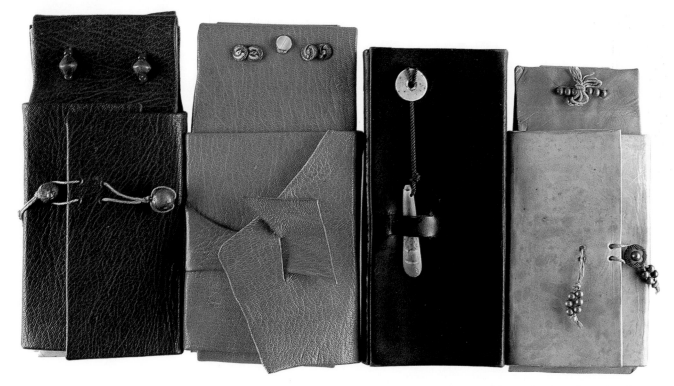

PHOTO: ERIC E. MITCHELL

Rivers, Night, Weather, Forests, Sky, Plants and Trail Guide to Stove Park, belt books by Claire Owen, Turtle Island Press.

THERE HAS BEEN AN EXPLOSION in book arts in the last decade. It has resulted from explorations by many artists into nontraditional structures and traditional but lesser known binding techniques. These artists have shown a willingness to develop text, even to write text, rather than simply to rebind existing books. For many, the initial stimulus was to use books to house artistic images, such as prints or photographs. Then books themselves became the means of expression. Books enabled artists to combine visual art and thoughts within a single structure.

This explosion isn't limited to artists, though. Books are springing up everywhere. Elaine S. Benjamin says, "I did my first books for my sons twenty years ago when they were small. With all the preplanning and labor that goes into one, a handmade book is really a way to say, 'I love you.' With my newly learned binding skills, now my work is truly a way to honor my friends and family."

The term *book arts* refers to all types of handcrafted books, including blank books, rebinds, albums, journals, and artists' books. Artists' books are those that combine structure (or technique), format, visual images, and presentation. Text is optional—some artists' books are strictly visual.

With books, structure is almost synonymous with technique. Either word refers to the method used for binding the book (e.g., pamphlet, stab-bound, codex). Seven of the chapters in this book describe a wide variety of binding structures/techniques. Format is the shape and style of the book. There are so many format options available within each technique that format ideas have

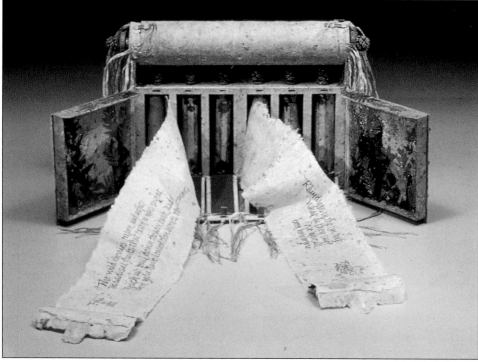

Above and left: *A Vision*,
Jenny Hunter Groat, with
seven poems by Wendell
Berry. From the collection
of the National Museum of
Women in the Arts. W.
Berry poems, *A Vision
from Clearing* and six
poems from *A Part*,
originally published by
North Point Press,
a division of Farrar,
Straus & Giroux, Inc.

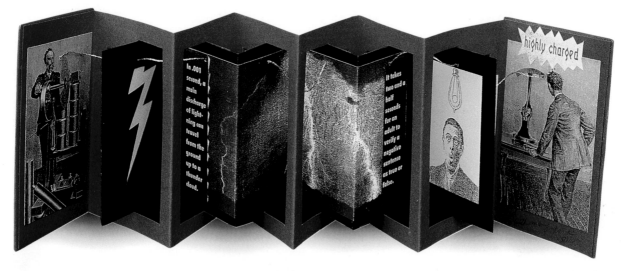

Highly Charged, Kathleen Amt, Plunder Press.

Ruled pad folder, Barbara Heisler.

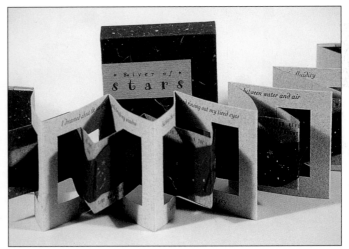

River of Stars, Julie Chen and Edward H. Hutchins,
Flying Fish Press.

been included with each technique chapter. Presentation is the look of the finished piece. A simple example is a Christmas present. Regardless of what's inside, some gifts are wrapped so beautifully that the wrapping itself becomes a joyful present. The last chapter is on presentation.

Finally, one of the great joys in art is *transmutation*. We all learn from others' ideas. The process of adapting these new ideas to our tastes and needs is transmutation. Hedi Kyle has been a driving force behind the explosion in book arts and has taught new structures to many people. Consequently, she promotes transmuta-

tion. Edward H. Hutchins learned a structure from her and suggested it to Julie Chen when they collaborated on *River of Stars*. He also showed it to his friend Kathleen Amt, who adapted it in *Highly Charged*.

Please continue the tradition and keep the explosion alive by taking everything you learn from this book and adapting it to your own taste and style. Choose your favorite colors, paper, and fabrics. Add a visual "signature." This can be something as simple and effective as the small collage of rice paper that Barbara Heisler added to her untitled folder. The small bits of paper are arranged into floral patterns that create her signature.

THE FINAL RESULT of the binding process—a book—is a familiar sight to everyone. Perhaps less well-known are some of the materials, tools, and techniques used to make one. This chapter describes the papers, boards, adhesives, and other materials that go into books, as well as the tools and techniques employed to assemble them. In addition to marking, scoring, cutting, and pasting, you'll learn how to fold paper into pages and how to determine which page goes where after folding. The vocabulary of bookbinding will be covered briefly; it's possible to make many lovely books without knowing the terms, but it's hard to make those books without having mastered the techniques..

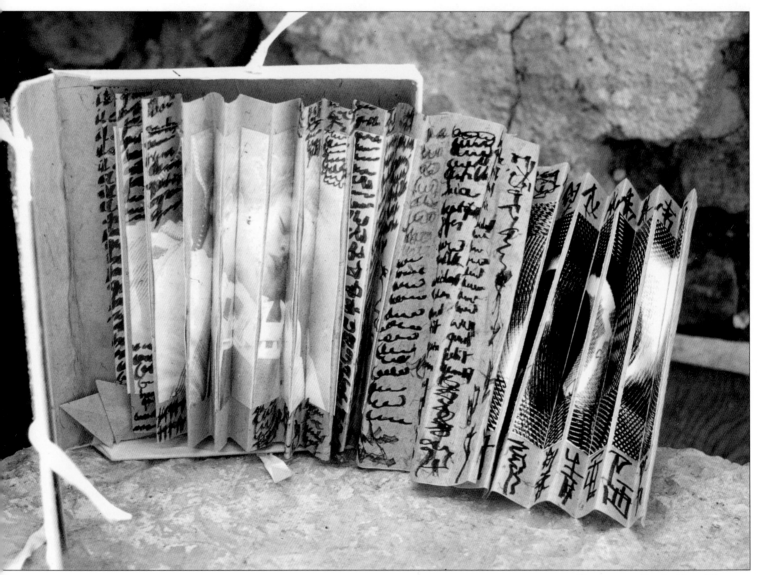

Harmonica Book, Aliza Thomas.

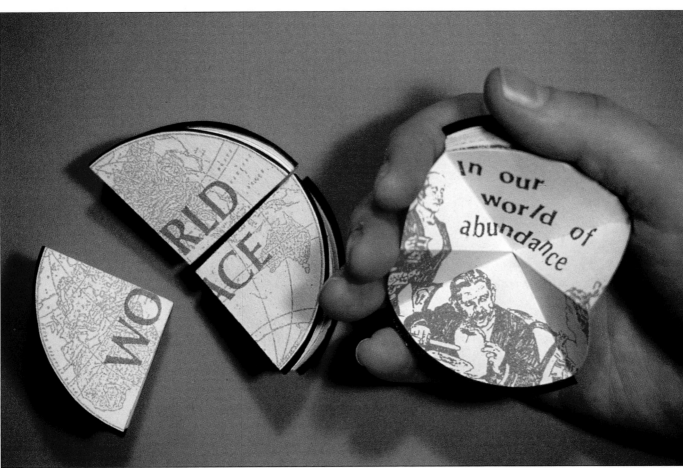

World Peace, Edward H. Hutchins.

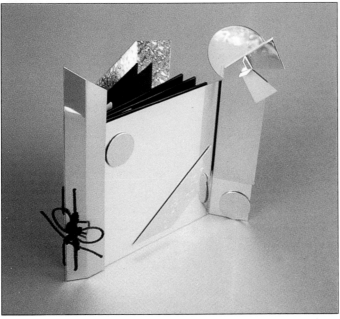

Click's Disk Book, David LaPlantz.

WHAT IS A BOOK?

When we think of a book, most of us visualize the type of object we find sitting on a library shelf or displayed in a book store. But the range is much greater than that. Books vary widely in size, from miniatures to lap-sized notebooks and journals. They can have vastly different shapes and styles also. While a familiar library-style book has rectangular pages made of single sheets all bound together along one side, other books have pages cut or folded into unusual shapes. Often fine prints are left unbound and placed as a group in a wrapper or a box. Other books have several accordion folds that allow the pages to expand or radiate outward.

Similarly, how do we define a page? If a page is something that has information or imagery on it, then is a computer disk a page? A page made of paper can be folded to make an interesting shape or to cover the message it carries. Bags or envelopes also can be pages.

THE PARTS OF A BOOK

As shown in figure 1, each part of a book has a name. The cover consists of three boards—front, back, and spine—which provide support to the book. Between each cover board and the spine is a groove that allows the pages to be opened fully. The top of the book is called its *head*, the bottom is the *tail*, and the side opposite the spine is the *fore edge*. The *endpapers* are folded sheets—often of specially decorated paper—placed at the inside front and back covers.

The text block, or contents of the book, is made up of groups of pages called *signatures*. A signature consists of a number of pages formed by folding a larger sheet, called a *parent sheet*, one or more times. The number of sheets in a signature can vary according to the thickness of each page and the effect desired. In commercial book printing, a signature is four sheets of paper that are folded and printed on both sides, equalling 16 pages.

If the parent sheet is folded once in half, it makes a *folio*. If folded in quarters, it's a *quarto*. If folded again, it's an *octavo*.

Parent sheets that are folded more than once offer both advantages and disadvantages for hand bookbinding. They allow a larger number of pages to be printed at once, which means less effort for printing, but more than one fold per sheet causes wrinkles. One solution is to print the parent sheet, cut it into sections, then fold each section once in the center. Even if the parent sheet isn't being printed (e.g., for a journal), it's neater to cut it before folding.

When working with parent sheets and signatures, the *imposition* becomes important. Imposition is where each page falls on the parent sheet. Page 1 can't be printed next to page 2 and still end up in the correct order in the book. Figure 2 shows a rectangular sheet of paper folded into quarters—a quarto. It also shows how you would number the resulting pages. When the parent sheet is reopened, the numbers indicate where each page should be printed (Fig. 3).

This doesn't mean that for every size and for every number of folds another set of imposition numbers has to be memorized. Impossible! Instead, make a quick model. Fold a piece of scrap paper the same number of times and the same way the parent sheet will be folded. Don't cut the folded edges. After numbering each page in order, open the paper to reveal the page numbers in their proper places.

This folding and numbering technique also works for signatures. Before placing any words or images on the pages, nest all of the sheets of paper for each signature together. Then number them. When the pages become separated, the numbers will ensure that they can be reassembled accurately.

In the following pages, you'll learn several methods of *binding* books and become familiar with some of the many *formats* that books can have. Binding refers to the basic mechanics of how a book is held together—the manner in which it's sewn, folded, or pasted—and format indicates the style in which it's made—its size, page shape, layout, and materials. Within a single type of binding, books can have many, many different formats.

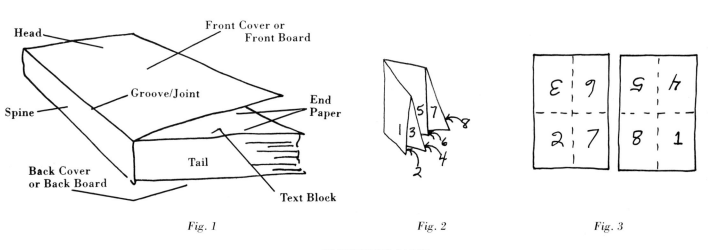

Fig. 1

Fig. 2

Fig. 3

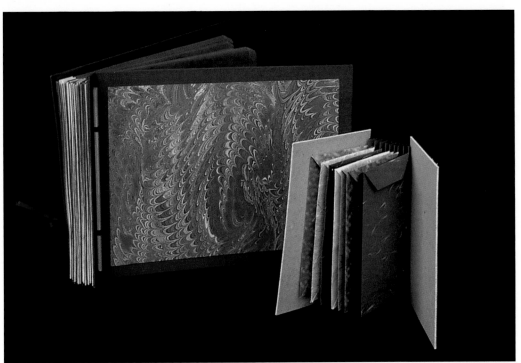

Untitled models, Dolores Guffey and Shereen LaPlantz.

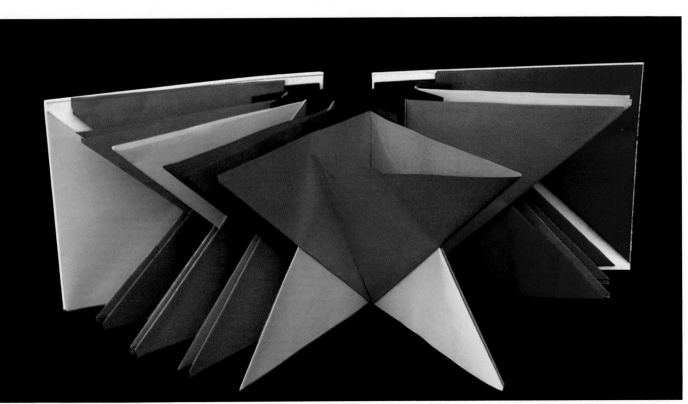

Untitled model, JoAnne Berke.

MATERIALS

Paper

Selecting paper for the text is easy. Any type of photocopier, laser printer, or typing paper works well. (The one exception is erasable bond, which smears. Anything printed on it may rub off.) These papers come in several weights, all of which work for bookbinding. They also come in quite a variety of colors and patterns. They're available at stationery stores, office supply stores, and at many copy shops.

Other choices for text paper include printmaking, drawing, charcoal, watercolor, or rice papers. These papers tend to be more expensive than photocopier papers and are used less often for text when a large quantity is necessary. All are available at art supply stores and some hobby shops.

The selection is even greater for papers that can be used for covers. For these papers, simply go to an art supply store and get whatever looks interesting or lovely. Rice papers, drawing, watercolor, printmaking, charcoal, and calligraphy papers all work. Since the range is so wide, look for specific characteristics instead.

A good cover paper is durable (doesn't come apart when a thumb is rubbed over it), flexible (doesn't crack if folded) and sturdy (doesn't pull apart easily). Unryu or unryu T rice papers are excellent for making covers. In addition to all of the above, they are forgiving—they gently grow, shrink, or slip to fit where necessary without pulling apart. Plus they're durable enough to act as hinges. They come in quite a variety of weights, surfaces, and colors.

Another option for covers is book paper, which feels like a combination of paper and fabric. It has a woven texture, and it's extremely strong. It tends to come in colors similar to those of construction paper and is available from bookbinding supply houses.

Endpapers are usually decorative papers, and they don't need to be as sturdy, flexible, and durable as cover papers. Marbled papers are the most commonly used endpapers, but there are lots of other decorative papers on the market. When shopping for endpapers at your local art supply store, ask to see their paste papers and Japanese papers. Gift wrapping paper may also work. It tends to crack when folded often, but it can be used in some applications.

Some papers (and other binding materials) are *archival*, which means they're pH neutral—neither acidic nor alkaline—and they're expected to remain chemically stable. Paper and paper products tend to be acidic, and this increases with age. Eventually paper can eat itself or eat into anything touching it, such as a print or photograph. Using archival papers and other materials is important if the book is expected to last a long time. For the book itself to be archival, every product in the book must be archival; using archival paste won't save a photograph that is placed next to acidic paper.

Fabric

Fabric is another alternative for making covers. (Twenty-five years ago, when I first learned bookbinding, we weren't allowed to use paper for our book covers; only fabric would do.) Again, look at the characteristics of your chosen fabric. It's preferable if the fabric doesn't fray or distort too easily and doesn't have stripes or checks. (They're almost impossible to line up properly.) If the fabric is very thin, the adhesive will seep through. Sometimes corners poke through loosely woven fabrics.

Boards

A hardbound book uses boards (such as mat board) to make a stiff cover that is strong and durable. These boards are most often completely covered by a lovely paper or fabric and, therefore, don't need to be visually attractive. Regular cardboard, or corrugated board, is not a good choice, since it dents easily. A better choice is one of the many types of solid board, which are made either from several plies (layers) or from chip.

Examples of plied boards are mat board, poster board, and railroad board. All are available at art supply stores. One potential disadvantage with plied boards is that they may come unplied with age. In addition, very few brands are archival. Mat board is archival only on the surface.

Inexpensive chipboard is carried by most art supply stores, and you can find higher grade material at bookbinding supply houses. High-grade board, sold under brand names such as Davey board, is quite a bit heavier than ordinary chipboard and is archival.

One other kind of board to use for covers is museum board. It is a type of chipboard, but it comes in single-ply, two-ply, and four-ply varieties. It's an archival board that is sold mainly though archival supply houses and sometimes through bookbinding or art supply stores.

Metal, buckram (a stiff fabric), and foam board also work for cover boards.

Adhesives

In general, adhesives can be categorized either as pastes or glues. Pastes are usually plant products, such as wheat starch, and glues are usually animal products or synthetics. Recommended adhesives for hand bookbinding include methyl cellulose, polyvinyl acetate (PVA), wheat or rice starch paste, and YES paste (a wheat starch and glycerine compound). All should be available from bookbinding supply houses.

Glue sticks are a fast, simple alternative for adhering paper. Some brands are archival and some are not. Glue sticks are expensive and awkward to control when adhering large surfaces, but they're great for *tipping in* (attaching a single page to a book by adhering one edge to another page).

Keep in mind that if the adhesive is archival, anything added to it will change its chemistry and probably alter its archival qualities. Therefore, when thinning with water, use distilled water.

Note: Not all adhesives are equally safe to use. The glue most often used in traditional bookbinding is made from the hides, bones, or cartilage of animals. My own recent experience with animal skin glue has been very unfortunate. The presence of the glue in my studio—still in its unopened container—caused three people to experience dizziness, headache, nausea, and other discomforts. As a result, I have not included animal skin glues in my testing and cannot advise using them.

The important characteristics of the recommended adhesives are listed on the following pages.

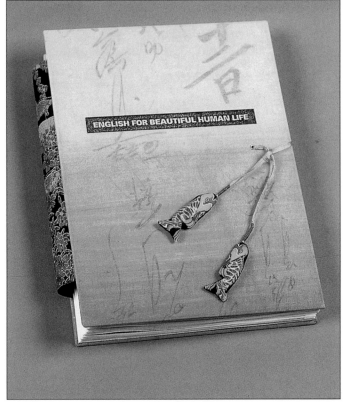

English for Beautiful Human Life, Kathleen Amt.

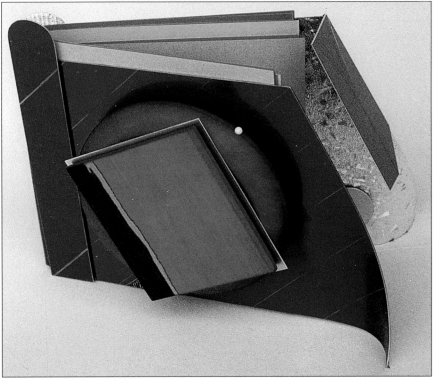

Artist's Book #2, David LaPlantz.

Methyl cellulose

- Archival
- Reversible
- Low tack (not an aggressive adhesive)
- Dries slowly
- Will show on the surface but can be cleaned off with water
- Must be mixed (instructions on package) and may be thinned with water
- Apply with brush
- Available from large art supply houses and paper-making supply houses

Note: I find this adhesive works best if mixed 24 hours before it's used. At first it seems to have no tack rather than low tack. I keep a pot mixed on the work table and add water as it dehydrates.

Polyvinyl acetate (PVA)

- Not archival
- Creamy white glue sold under several brand names, including Elmer's and Sobo
- Not reversible
- Dries rapidly
- Will show on the surface and usually cannot be removed
- May be used straight or thinned with water or wheat paste (In a separate jar, mix it 50/50 with the wheat paste.)
- Apply with brush
- Available almost everywhere, including craft shops, variety stores, hardware stores, and grocery stores

Note: PVA formulas differ according to brand, so the characteristics may vary. Those made for use on wood are more acidic and less flexible than those made for bookbinding.

Wheat starch paste (also wheat flour paste, rice flour paste, etc.)

- Archival
- Reversible
- Some varieties are food grade
- Dries slowly
- Must be mixed, cooked, strained, and thinned with water
- Must be refrigerated or may turn rancid
- Apply with brush
- Available from bookbinding supply houses

Note: The cooked variety is smooth and translucent, like cooked corn starch. The uncooked type, often sold as wallpaper paste, is grainy. Uncooked wheat starch doesn't seem to need refrigeration; it dries into a shriveled cake first. The cooked wheat starch is so wonderful to work with that it's worth the extra effort to cook, strain, and refrigerate it.

YES paste

- Brand name for a paste made of wheat starch and glycerine
- Archival
- Reversible
- Dries relatively rapidly
- Will show on the surface
- May be used straight from the jar or thinned with water (Thin either by adding about 20 percent water and mixing thoroughly or by using a wet brush. If used straight, apply it with a plastic knife or piece of cardboard; if thinned, apply it with a brush.)
- Available from craft shops, hobby houses, and art supply stores

PHOTO: SHEREEN LAPLANTZ

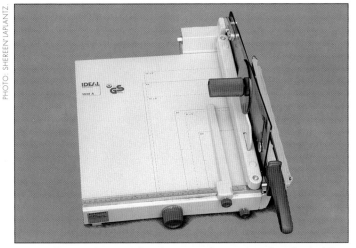

Paper cutter with safety guard, pressure bar for holding paper in place, and size guide.

Thread

Any really strong thread, such as bookbinders' linen, waxed linen, upholsterers' thread, buttonhole, or carpet thread can be used to sew individual signatures together. Don't use dental floss—it stretches—or regular sewing thread—it's not strong enough. Be especially careful that the thread chosen doesn't stretch. Stretching tends to happen after the book is finished, eventually ruining your project.

For books where the stitching will show, any number of decorative threads, cords, and ribbons can be used. Crochet, beading, or decorative sewing threads can all be used as long as they are strong.

TOOLS AND EQUIPMENT

Cutting Tools

Paper and board may be cut by hand or with a paper cutter. When cutting by hand, use a craft knife or mat knife and a metal straightedge to guide the cut. Change the blades in your knife frequently; paper dulls a knife rapidly, and a sharp knife really does cut best.

Of the two types of paper cutters available, the one most of us are familiar with has a bed, usually gridded off to match a ruler at the top, and a cutting arm with a blade. The operator must control the paper. This type of cutter works well in an office or school room where precise cuts aren't necessary.

The other type of paper cutter has all of the above plus a pressure arm, something that comes down to hold the paper precisely in place during cutting. This provides a more exact cut, especially when making the very narrow cut required for the spine. (A cut of 1/4 inch or so—about 6 mm—doesn't allow much room for wobble.) It has a much sharper blade than a regular cutter, which results in a cleaner cut. Additionally, this type of cutter usually has a safety wall and a moveable extension that supports the paper being cut. It's made to cut multiple sheets of paper at once (even an entire text block) and to cut through board.

Bone Folders

Bone folders are made specifically for scoring paper to make neat folds. They're available from bookbinding supply houses and some large art supply stores. If they feel a little thick and coarse when first bought, sand them down to fit your hand. (This means sanding a polymer plastic, so use a mask and provide plenty of ventilation.) Burnishers used for transfer lettering are also effective. Use whatever tool gives you a solid, clean score line.

Hole-Punching Tools

Many different tools can be used for punching holes into paper, and a rubber mallet or hammer helps to force a hole through a thick stack of paper. Use a rubber mat or other firm padding underneath to prevent the sharp tool from digging into your work surface.

Bone folders, burnisher at top.

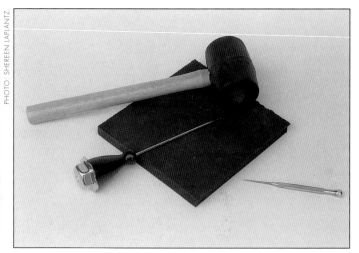

Awl, pin vise, rubber mallet, and rubber cushion.

Awls, ice picks, and nail punches all work, but these tools all leave a slight ripped edge on the back of the paper. A hand-held paper punch leaves a clean surface, but it cuts through only a few pages per punch. Either a Japanese hole-punching set, which is available from bookbinding supply houses, or a hole-punch set from a hardware store will make clean cuts and punch through many pages. These sets are also capable of making holes in several sizes.

Drill presses can drill a hole simultaneously through the covers and text block. Be careful to clean out the drill bit after each hole; otherwise, the paper edges become rough and thick.

Needles

Although bookbinding needles are available, any large-eyed, blunt-ended needle will work. Tapestry and darn-ing needles in sizes appropriate for your thread or cord are fine. Be sure the end is blunt to avoid pricking any extra holes into your text or cover.

Adhesive Brushes

Most glues and pastes work best with inexpensive flat brushes made from synthetic fibers. Brushes from hardware or paint stores work better than the wonderful brushes from art supply stores. Hot glues, such as animal hide glues, work best with special bookbinder's adhesive brushes (available from bookbinding supply houses).

Book Press

After any pasting process, the item will be smoother and will lie flatter if it dries under weight. A large, heavy book works well. If you make many books or will be

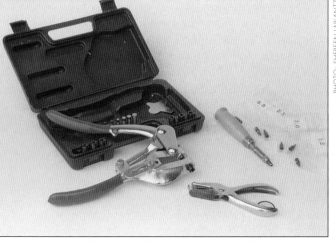

Power punch, screw punch, and paper punch.

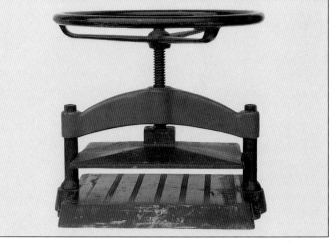

Book press.

making editions, a book press is well worth the invest-
ment. It adds that much more pressure to the pasted cover
or finished book, and the result will look professional.

BASIC TECHNIQUES

Folding
To get a clean fold, you must use something to score
the paper. First measure where the fold belongs, and
mark the measurements. Holding a ruler or straightedge
along the marks, run the bone folder along the ruler
hard enough to make a pressure score, or groove.
Without moving the ruler, fold the paper up by running
the bone folder on the outside of the fold, pressing it
harshly against the ruler. Finally, remove the ruler and
flatten the fold by running the bone folder over it.

This last step may cause the paper to become shiny.
That's prevented by laying a piece of scrap paper over
the fold, then running the bone folder over the fold and
the scrap paper.

Marking
When measuring a piece of paper or board for cutting,
a mark needs to be made at the measurement. A pen-
cil mark is thick enough to throw off the measurement.
Try using a very fine pen, technical pen, or a craft knife.
With the knife, use just the tip of the blade to make a
tiny cut, the size of a pin prick, into the paper. It's pre-
cise and nearly invisible, and it will be cut through later,
so no one else will ever see it.

Cutting
Cutting paper by hand is quite simple: measure and
mark your dimensions, lay a metal straightedge next to
the marks, and make the cut with your knife.
Unfortunately, it's as easy to cut a hand as it is to cut a
piece of paper. Consequently, I advise using a filet
glove when cutting with a knife. This glove will protect
your hand from cuts, even when you cut directly into it.
It's light and flexible, and it can be found at fishing tack-
le supply stores or in some discount stores.

Paper cutters save lots of time plus wear and tear on
the hands; however, they also demand a safety
reminder. Paper cutters can cut you as easily as paper.
Work responsibly, keep your body parts away from the
blade, and don't let a child operate a paper cutter.

Cutting something very narrow, such as a book's spine,
can be tricky using a paper cutter. To make it easier,
add the narrow piece to a larger piece, and cut the

total. Then cut the proper size for the larger piece from
the total. The smaller piece will be cut off automatical-
ly. For example, if a cover is 6" (150 mm) wide, and
the spine is 3/8" (10 mm), the board would be cut first
at 6-3/8" (160 mm) and again at 6" (150 mm).

Punching Holes
Traditionally, sewing holes are poked into the spines of
signatures (and even covers) using a sewing cradle.
This is a V-shaped trough with supporting legs. The sig-
nature is placed into the trough, opened, and a punch-
ing jig is laid inside the signature. After punching, all
of the holes for all of the signatures line up perfectly.

You can make your own jig with any lightweight board.
Cut it about 2" (50 cm) wide and fold it in half length-
wise. Then measure and mark where the holes go. With
the jig lined up on the signature, just poke holes through
every mark.

Most sewing cradles are made of wood, although
heavy board also works. If you're making an entire edi-
tion, a sewing cradle saves time. If you're making a
model, simply follow the directions in the codex and
stitches chapters: Make a pencil mark across the spine
folds and poke the holes with an awl or push pin.

Applying Adhesives
Use plenty of scrap paper or newsprint under the project
when applying adhesives. Whenever the scrap paper
moves, or you think the adhesive might get onto the wrong
surface, throw away the used paper and replace it with
new. This seems wasteful, but any adhesive that dries on
the book's surface will show. Then the whole book has
to be thrown away, and that's even more wasteful.

When adhering paper to a board, apply the adhesive
to the paper; then position the board onto the paper. This
method usually gives a smoother adherence, and it's eas-
ier to make the moistened paper wrap around the board's
edges. When working with cloth, apply the adhesive to
the board because it will seep through the cloth.

Apply the adhesive to the center of the paper, and brush
outward toward the edges. Brushing outward gives the
adhesive less opportunity to get under the edge and
ruin the good surface.

A bowl of water and towels should be kept handy when-
ever pasting or gluing. Washing your fingers often will
help keep the adhesive from going where you don't
want it. Any glue or paste that gets in the wrong place
usually can be wiped off with a damp paper towel. Be
careful not to abrade the surface by rubbing too hard.

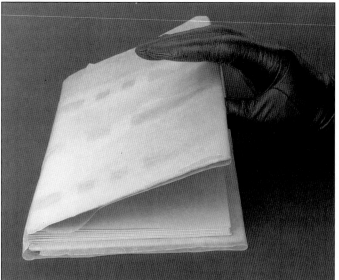

Wrapping the book after pasting.

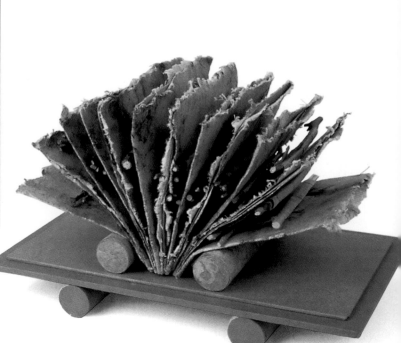

Spirit Book #7: Sacred Speaker, Susan Kapuscinski Gaylord.

Drying

After pasting or gluing the cover, wrap the book in waxed paper to dry. The waxed paper prevents the paste or glue from getting onto the wrong surfaces. Wrap the waxed paper around the entire outside cover, starting inside the front cover and finishing inside the back cover.

Dry all pasted and glued covers and books under a heavy weight to help them stay flat. A large, heavy book works, but a book press has that much more pressure, and the covers get a neat, flat finish.

A NOTE ABOUT SAFETY

Most of the papers and fabrics used in bookbinding are not toxic, and the same can be said of some of the adhesives recommended in this book. Even so, please observe sensible studio practices. Do not do any studio activities in the kitchen—and that includes cleaning out brushes used for applying adhesives. Do not return any items borrowed from the kitchen and used in the studio. If you wouldn't eat the material, then there's no point in contaminating the kitchen with it so that it can be eaten later in small quantities.

For further information on art-related health hazards, the Center for Safety in the Arts has numerous books and a newsletter, *Art Hazards News*. Their address is 5 Beekman Street, Room 1030, New York, NY 10038, and their telephone number is 212-227-6220. There is also a Chemical Referral Center Hotline: 800-262-8200 (in Washington, DC: 887-1315).

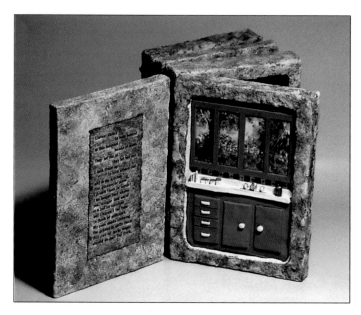

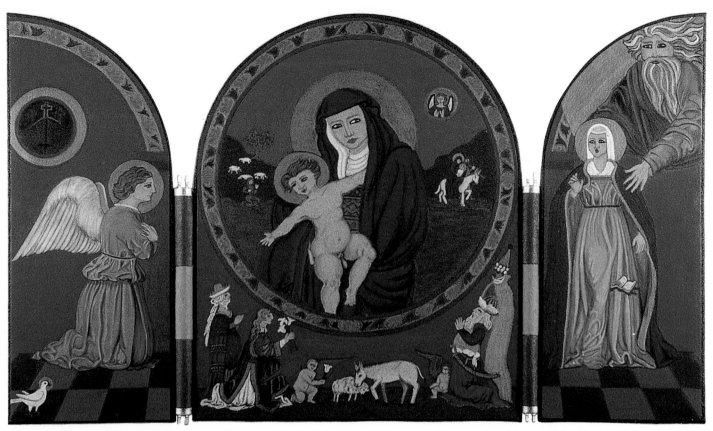

Two Hours of the Virgin, Elsi Vassdal Ellis.

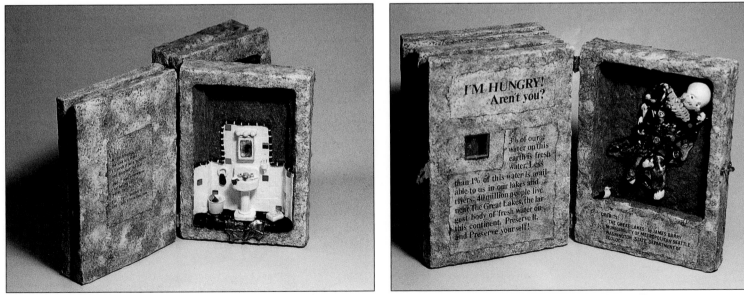

Above, left, and opposite: *The Doorbell Is Ringing*, Lynn A. Mattes-Ruggiero.

PAMPHLET STITCH

THE **PAMPHLET** or butterfly stitch is the easiest and one of the most versatile techniques to use in bookbinding. The basic pamphlet stitch uses three holes to sew through, but if the book or pamphlet is large, five or even seven holes may be used. It's also possible to sew two signatures together using the pamphlet stitch, creating a thicker book.

Untitled journals, Shereen LaPlantz.

Fig. 1

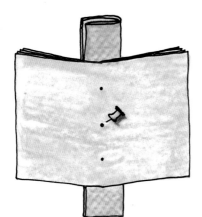

Fig. 2

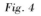

Fig. 3

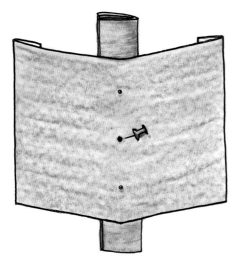

Fig. 4

PROJECT

A good place to start is with a simple three-hole pamphlet with a cover that has a folded in fore edge. The fore edge may be folded in either for strength or beauty.

Tip: In any type of binding, the cover's fore edge takes the most abrasion. If you want your book to last, make the cover's fore edge sturdy.

Materials

Text: 4 sheets, standard size, of any photocopier, laser printer, or typing paper

Cover: 1 sheet of any medium-weight art paper, cut as instructed below

Tie: 1 piece of narrow ribbon, yarn, waxed linen, or strong twisted paper cord. You'll need a piece about 3-1/2 times the length of your pamphlet's spine.

Tools

Bone folder or similar tool

Craft or mat knife

Metal-edged ruler or ruler plus metal straightedge

#18 tapestry needle or any large-eyed, blunt-ended needle

Tea towel or paper towel folded into quarters lengthwise

Push pin, awl, or equivalent

Process

1. Measure and cut the cover sheet 1/2" (13 mm) taller than the text paper. For a narrow fold-in at the fore edge, cut the cover 3" (76 mm) wider than the text; for a deep fold-in, make it 10" (254 mm) wider.

2. Score and fold the cover paper in half. Then mark 1-1/4" (32 mm) in from each fore edge for a narrow fold-in or 4-3/4" (121 mm) for a deep fold-in. Score and fold both sides inward (Fig. 1). Set the cover aside. (The fore edge may be folded in as deeply as you wish; just allow for that amount when originally measuring and cutting the cover.)

3. Fold the four text sheets in half. Slip one inside another until the four sheets nest together as a signature (Fig. 2).

4. Open the signature and place it on top of the folded towel. Along the fold line, measure the center and poke a hole there with an awl or push pin. Then make two more holes, one about 1" (25 mm) down from the

head, the other the same distance up from the tail (Fig. 3).

5. Open the cover and lay it on top of the folded towel. Measure and poke a hole at the center of the fold line. To allow for the overhang, measure and make the top and bottom holes 1-1/4" (32 mm) in from the edges (Fig. 4).

6. Nest the signatures inside the cover, making sure the holes match up. After threading the ribbon or cord through the needle, begin sewing by passing from the outside to the inside through the center hole. Leave a tail of ribbon long enough to tie a bow or knot later (Fig. 5).

7. Sew up to and out of the top hole (Fig. 6).

8. Sew down the outside and into the bottom hole (Fig. 7).

9. Sew back out through the center hole, making sure to sew through the hole, not the ribbon. The ribbon ends must be on opposite sides of the long stitch if you want to tie a bow or knot around that stitch (Fig. 8). Adjust the ends if they're not on opposite sides, and tie a bow or knot (Fig. 9).

10. Trim off any excess from the ribbon ends.

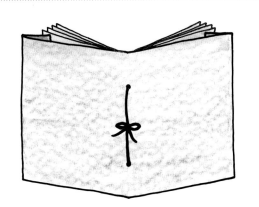

Fig. 9. Finished book

Note: Pamphlets can be any size desired; usually the text paper dictates the cover size. To hide any slight variations that occur in folding or sewing, the cover is made to overhang the signature by 1/8" to 1/4" (3 to 6 mm) on all three edges. It's possible, and even common, to have a significantly larger cover than signature. This can give stature to a few sheets of paper.

Fig. 5

Fig. 6

Fig. 7

Fig. 8

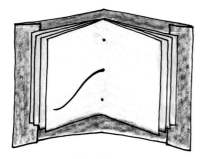

Fig. 10

Fig. 11

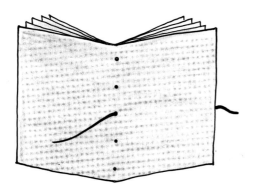
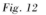

Fig. 12

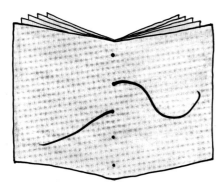
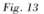

Fig. 13

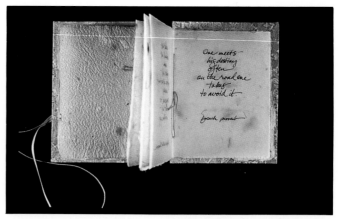

Untitled, Nancy McIntosh.

INSIDE BOW OR KNOT

One variation on the basic three-hole stitch has the bow or knot tied inside the signature. Begin with a cover and signature, whatever size and style you wish. Poke three holes, just as you did for the project pamphlet, but start sewing from the inside of the signature (Fig. 10).

If you start with the tail of the ribbon on the inside, then you must end on the inside. Therefore the knot or bow is on the inside (Fig. 11).

FIVE-HOLE PAMPHLET STITCH

Five holes are used when the book or pamphlet is larger or will be used often and needs more stability. Making a three-hole pamphlet stitch is speedier, but five or more holes provide greater security and permanence.

Prepare the cover and text signature as you did for the project, remembering to allow an overhang of 1/8" to 1/4" (3 to 6 mm) on all of the edges. Now poke five holes into the center folds. Usually it looks best if the holes are evenly spaced, but that is a design decision.

As with all pamphlet stitches, start sewing in the center, leaving a tail of ribbon on the outside (Fig. 12). Come out of the hole directly above the center hole (Fig. 13), and enter the top hole (Fig. 14). Then sew back down, coming out of the second hole (Fig. 15). This simple in-and-out stitching is called the running stitch.

Now you're at the long stitch, the part that identifies it as a pamphlet stitch. Sew past the center hole and into the fourth hole (Fig. 16). Bring the needle out through the bottom hole (Fig. 17). Finish the bottom half by sewing back up into the fourth hole (Fig. 18) and back out through the center hole (Fig. 19).

Fig. 14

Fig. 15

Fig. 16

Fig. 17

Fig. 18

Fig. 19

Fig. 20

Fig. 21

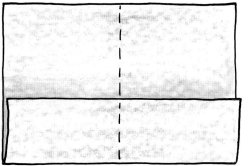
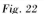

Fig. 22

Fig. 23

Fig. 24

Fig. 25

When making the final stitch, try not to sew through the existing ribbon, yarn, or thread. Also remember to have the ends on opposite sides of the long stitch. Then tie the bow or knot and trim off any excess (Fig. 20).

For seven or more holes, simply extend this process.

COVER VARIATIONS

A pamphlet cover may be simple or have folds on different edges. The simplest cover has no folds, not even on the fore edge (Fig. 21). Folds at the fore edge provide strength, and folds across the tail can become pockets.

To measure a cover with a bottom pocket, decide on the size of your book or pamphlet. Double the width, plus the overhang, so that it can be folded in half. Then decide how deep you want the pocket. Add that amount to the height of the cover plus overhang.

Now score and fold the cover as shown in figure 22. Sew in the signature, and it's done (Fig. 23).

To create an outside pocket, make the fold on the outside of the cover rather than on the inside (Fig. 24).

When an idea is a good one, keep making variations. One more sheet of the cover paper, folded, adds two more pockets. To do this successfully, make the fold in the actual cover fairly shallow—about 3" (75 mm). Then fold the extra piece of cover paper not exactly in half (Fig. 25).

Slip the extra folded piece inside the cover's pocket. After poking holes through both the cover and pocket insert, sew the signature in place (Fig. 26).

Both the fore edge and the tail may be folded in if desired (Fig. 27), but the double layer of folds at the corners can get bulky. If that becomes a problem, trim one of the layers away (Fig. 28) before folding (Fig. 29).

Of course the head may also be folded inward (Fig. 30). When all of the edges are folded in, the book or pamphlet has a very finished, tailored feeling to it. Again it might be bulky where there are double layer folds, so trim the head as you did the tail in the previous example.

TWO-SIGNATURE PAMPHLET

Normally pamphlet stitches work only on single signatures. However, if the cover is pleated at the spine, then two signatures may be sewn in at once.

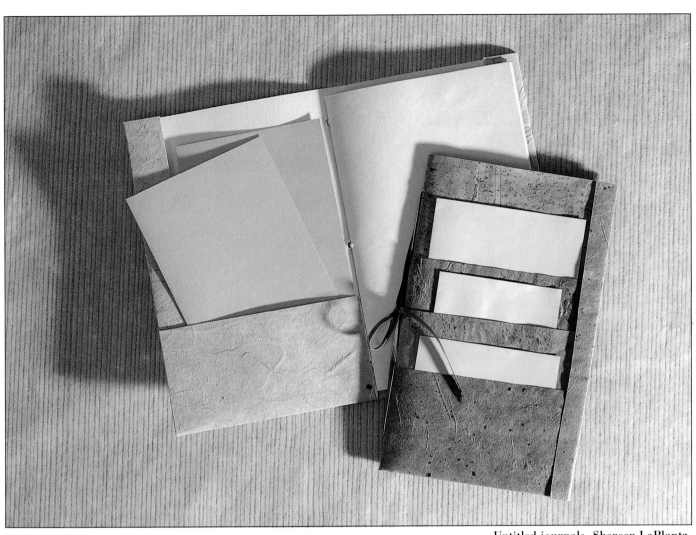

Untitled journals, Shereen LaPlantz.

Fig. 26

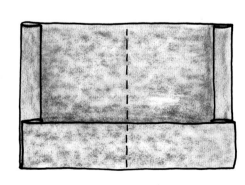

Fig. 27

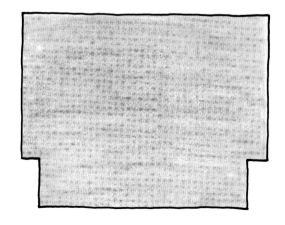

Fig. 28

PAMPHLET STITCH

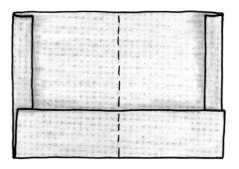

Fig. 29

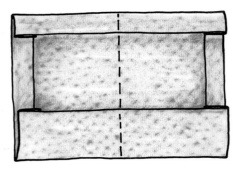

Fig. 30

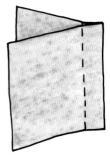

Fig. 31

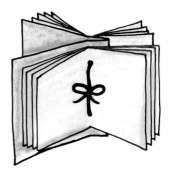

Fig. 32

The width of the cover must be twice the width of the signatures, plus overhang, plus enough to fold in between the two signatures. Add at least 1" (25 mm) on each side, or 2" (50 mm) total extra width for the folded portion.

3-Piece Dreams, Judy Dominic and Ginny Dewey Volle.

Fig. 33

Score and fold the cover so that the spine makes an M instead of a simple V (Fig. 31). After making two signatures, lay them onto the center folded section (Fig. 32) and poke the necessary holes (three holes are illustrated). Sew the pamphlet stitch simultaneously through both signatures and the center folded section—the combination acts as a single unit (Fig. 33).

FORMAT VARIATIONS

Pamphlet stitch is the technique; how it is used becomes the format. A pamphlet stitch may create a simple pamphlet, such as the whimsical dream catcher *3-Piece Dreams* by Judy Dominic and Ginny Dewey Volle, or the stately *Metamorphosis*. All use the same technique; only the format changes.

Because the pamphlet stitch is so quick and works with a single signature or a single piece of paper, it lends itself to cards. For those interested in making cards, there are several books available on Japanese folded cards and boxes.

In addition to making simple pamphlets, this stitch is good for attaching signatures to any of the more complex bindings, as Robin Renshaw did in her journal. She made a concertina (folded) section, attached signatures with a running stitch, then bound through the concertina to the back cover with a pamphlet stitch.

Metamorphosis, Shereen LaPlantz, Press de LaPlantz.

Card models, Robin Renshaw.

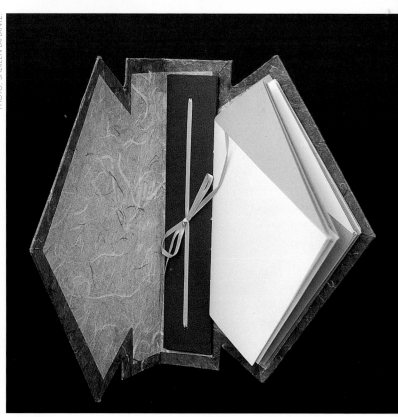

Journal, Robin Renshaw.

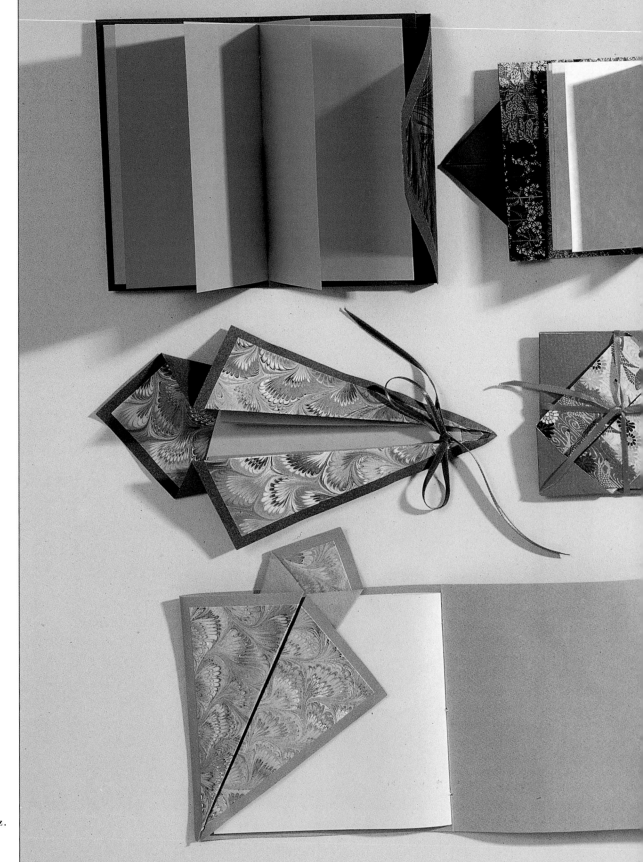

Pamphlet cards,
Shereen LaPlantz.

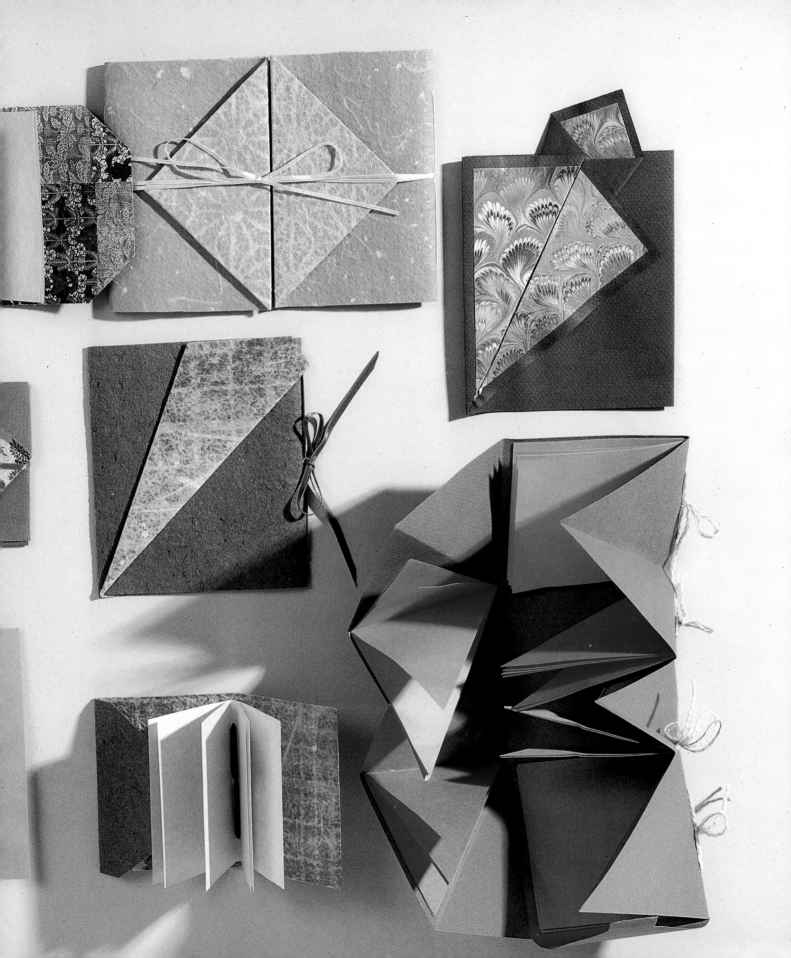

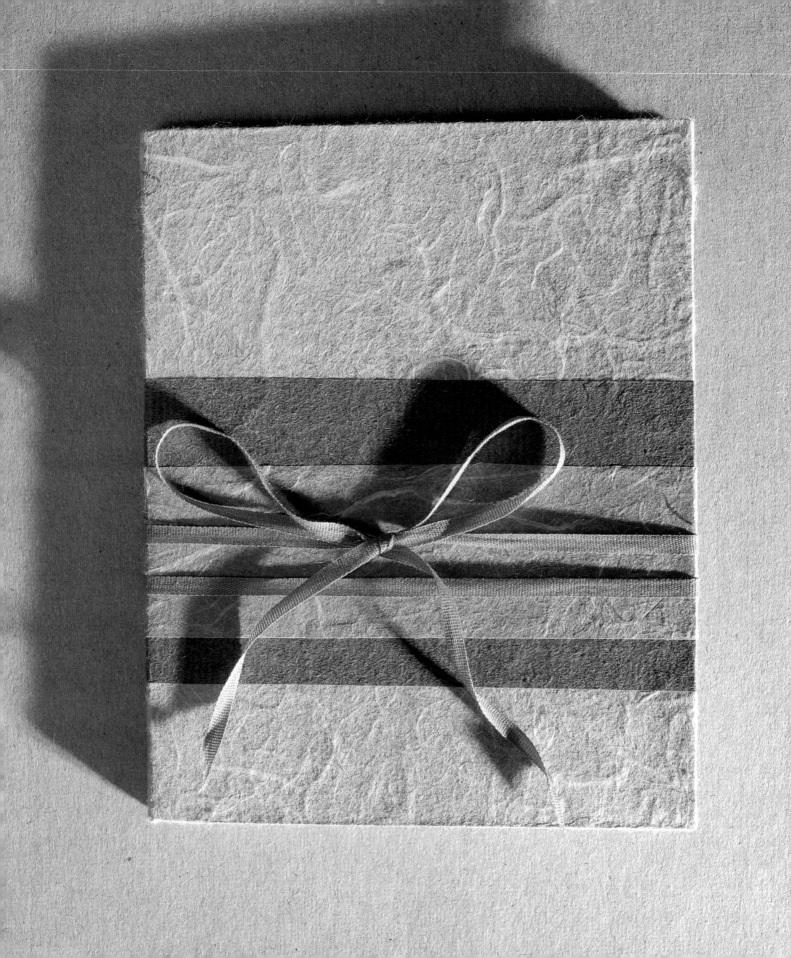

A CODEX is the type of book that we generally think of when we imagine a book. The signatures are sewn together at the spine, and they're protected by a hard cover on the front, spine, and back. A simple codex is delightful, and when made up as a quarto with ribbon ties, it feels special and precious.

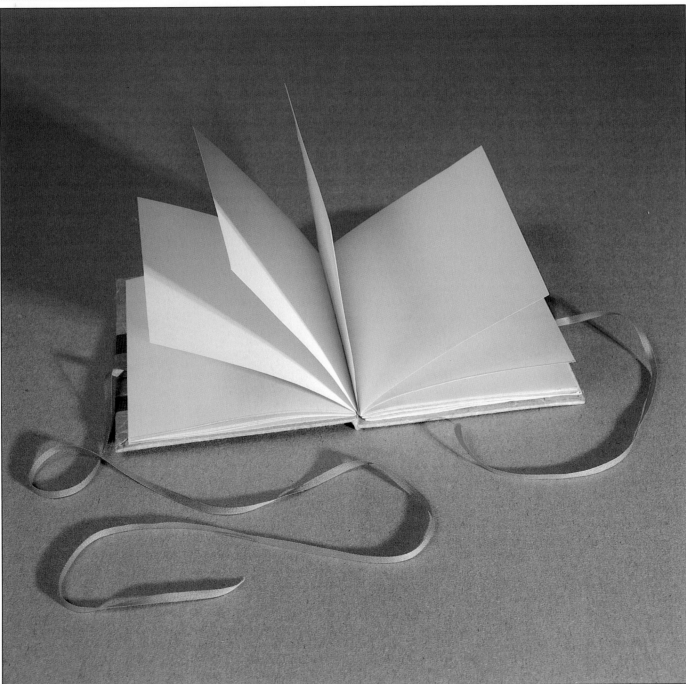

Opposite and above: Untitled journal, Shereen LaPlantz.

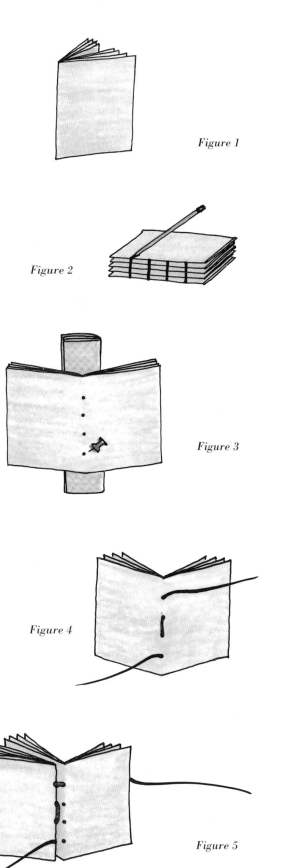

Figure 1

Figure 2

Figure 3

Figure 4

Figure 5

Project model, Shereen LaPlantz.

PROJECT

This is a simple, quarto-sized codex with a hard cover. It could be a journal, trip diary, scrap book, or photo album.

Materials

Text: 10 sheets of standard-sized photocopier, laser printer, or typing paper, each cut in half

Endpapers: 2 pieces of marbled or other decorative paper, cut the same size as the text paper

Cover boards: 3 pieces of any of the boards discussed on page 12, cut as described below

Cover paper: 1 piece of unryu or unryu T rice paper, medium or heavy weight, in any color and texture. See below for cutting instructions.

Thread: About 1 yd. (.9 m) of any really strong thread that doesn't stretch

Beeswax

Scrap paper for pasting

Waxed paper

Paste

Tools

#18 tapestry needle or any large-eyed, blunt-ended
 needle
Tea towel or paper towel folded into quarters length-
 wise
Pencil
Awl, push pin, or equivalent
Book press or large, heavy weight

Process

1. Fold each of the half-sheets of text papers into quar-
tos, and nest them into five signatures of four sheets (16
pages) each (Fig. 1).

2. Measure and cut two cover boards, each 1/8" (3
mm) wider than the text pages and 1/4" (6 mm) longer.
(This will give a 1/8" overhang on all three edges.)
Cut a third piece for the spine, making it 1/4" wide
and as long as the other two covers.

3. Cut the cover paper so that its width is equal to the
total width of the front, spine, and back cover boards
plus 2-1/4" (57 mm), and its height is 2" (50 mm)
greater than the height of the cover boards.

4. Stack the signatures on top of each other, lining up
the edges. With a pencil, mark four straight lines
spaced evenly across the spine (Fig. 2). These lines
indicate where to place the holes for sewing the sig-
natures together.

Tip: It's very important to keep the signatures in order.
If your pencil lines aren't perfectly straight and the sig-
natures change position, the holes won't line up and
the final text block will be skewed.

5. Lay the first signature on top of a folded towel. Now
poke holes through the spine fold at each pencil mark
(Fig. 3). Set that signature aside and repeat this process
on each signature.

6. If your thread is unwaxed, wax it by pulling it over
a lump of beeswax. Thread the needle and start
sewing, starting with the top signature. Sew a run-
ning stitch, a simple in-and-out up the spine (Fig. 4).
Leave a tail of thread hanging out; it will tie off with
the next signature.

7. The purpose of sewing the signatures together is
for them to be thoroughly joined into a solid text block.
Consequently, each signature must be joined (sewn
together) with its neighbor at every opportunity. Place

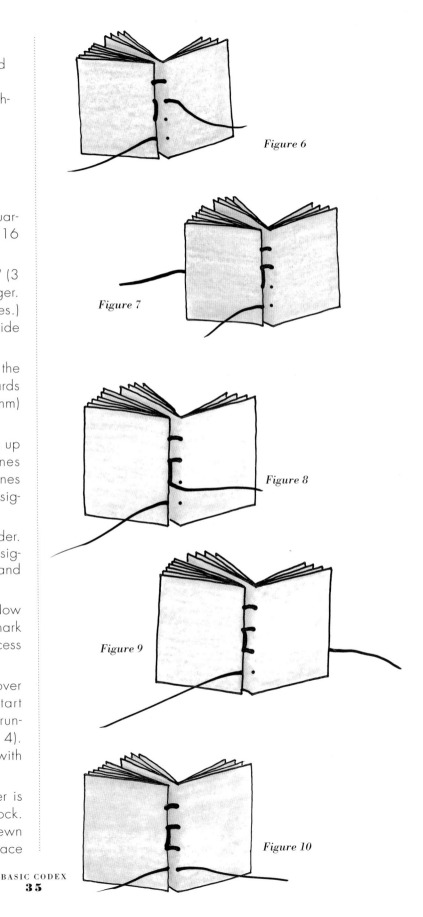

Figure 6

Figure 7

Figure 8

Figure 9

Figure 10

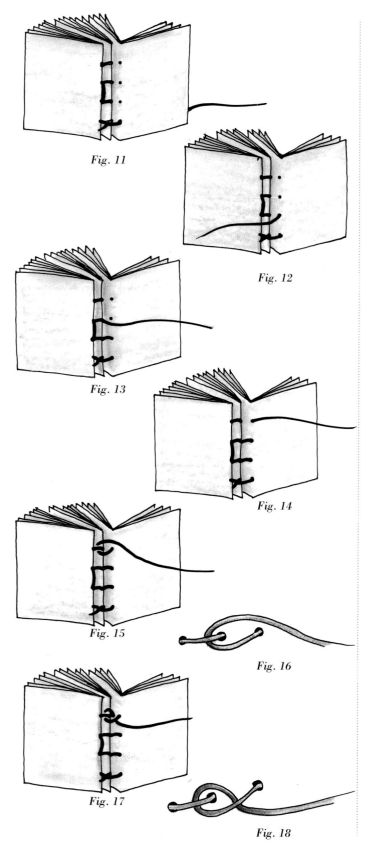

Fig. 11

Fig. 12

Fig. 13

Fig. 14

Fig. 15

Fig. 16

Fig. 17

Fig. 18

the second signature next to the first, and sew into the top hole, joining the two signatures together (Fig. 5). Then come out of the second hole (Fig. 6).

8. If the signatures were joined only at the head and tail, then there would be gaps in the middle. Join them by sewing into the adjacent hole, *in the previous signature* (Fig. 7). Then sew down and out the next available hole in the first signature (Fig. 8).

9. Now join everything together by sewing back into the new signature (Fig. 9).

10. When you sew out of the bottom hole, you will have two ends available (Fig. 10). Tie them together in a square knot, but don't trim any excess yet.

11. Place the third signature next to the two already sewn and join it by sewing into the bottom hole (Fig. 11).

12. Sew up to the next hole (Fig. 12). Remember, this is where the signatures can be joined; sew into the previous signature at the adjacent hole (Fig. 13).

13. Continue joining the signatures by sewing up to the next hole and back into the new signature. Finally, sew out of the top hole (Fig. 14).

14. It's time to add the next signature, but don't do it yet. If the next signature is added and the sewing continued as before, then the top portion won't be joined securely. Make it secure by sewing back under the previous top stitch. You may choose one of two stitches for this purpose—the simple stitch shown in figures 15 and 16 or, for something a little more secure and more in the tradition of bookbinding, the kettle stitch shown in figures 17 and 18.

15. Now add the next signature, repeating the same process. Sew down, then into the previous signature. Sew back into the new signature and out at the bottom (Fig. 19). Join the signatures at the tail either with the simple stitch (Figs. 20 and 21) or the kettle stitch (Figs. 22 and 23).

16. Continue, adding the next signature and repeating the sewing process. Tie off the end at the top with a couple of half-hitch knots (Fig. 24).

17. Trim the ends of both knots now, but don't cut them too short (Fig. 25). The knots will be completely hidden in the spine, and you don't want to take any chances

that the knots may pull loose because the ends have been trimmed too closely. (In fact, triple knots don't hurt and still won't show.)

18. Dab some paste on the spine. This is a light application and should be made only on the spine. Be careful not to let any paste run down onto the pages.

19. Now it's time for the cover. Lay out the three pieces of board as shown in figure 26. These become the front cover, spine, and back cover.

20. The unryu rice paper will cover the board, hold the pieces together, and make them pretty. Once the paste is on the paper, it's difficult to line up the boards perfectly without a guideline. Before applying any paste to the paper, measure 1" (25 mm) up from the tail and draw a light pencil line across the entire piece of paper (Fig. 27).

21. After spreading a thin, even coat of paste onto the entire surface of the paper, carefully place the boards on the guideline, spacing them 1/8" (3 mm) apart (Fig. 28).

Tip: The spacing between boards is critical. If you fudge and make the space narrower, then the book won't be able to close properly. If the space is too wide, the hinge

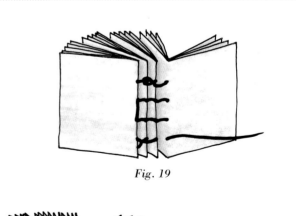

Fig. 19

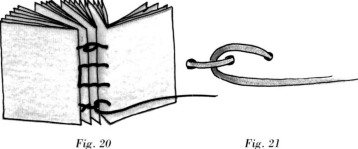

Fig. 20 *Fig. 21*

Fig. 22

Fig. 23

Fig. 24

Fig. 25

Fig. 26

Fig. 27

Fig. 28

Fig. 29

Fig. 30

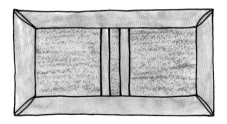

Fig. 31

Fig. 32

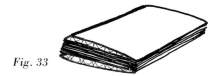

Fig. 33

may become wobbly and allow the cover to move out of alignment. The 1/8" (3 mm) spacing works well for any board with a normal thickness. If you're using something thicker, estimate 1-1/2 times the board's thickness for the open space. This allows a graceful, functional hinge. If you're using something quite a bit thinner, try a sample to be sure, but generally stay with 1/8".

22. There are several methods for making corners when covering boards. This method is called a *universal corner.* It's particularly good for fabrics and thin or supple papers.

Since the paper has already been pasted, it doesn't need to be pasted now. Fold in each corner, forming a perfect, or nearly perfect, little square on the corner (Fig. 29). Make sure that the paper's edge is tight against the board's corner, but not tight enough to tear.

23. Apply more paste to each of these new corners. Now fold in one of the short sides (Fig. 30). Be careful to pull the paper tightly, forming a sharp, clean edge, but don't pull so tightly that you tear or distort the paper.

24. Repeat, firmly folding in each side (Fig. 31). The cover boards are now complete.

25. Wrap the cover in waxed paper and place it in a book press or under a heavy weight to dry flat.

26. Once the cover is thoroughly dry, there are several methods for attaching it to the text block. One of the simplest, and the one chosen for this project, uses the endpapers to make the attachment.

Fold each of the endpapers in half (Fig. 32). Then apply paste to half of one endpaper, and attach it to the front, or first page, of the text block. Paste half of the other endpaper to the back, or last page, of the text block (Fig. 33).

27. Now apply paste to the unused half of the front endpaper. Carefully line up the spine of the endpaper with the back edge of the front cover, *not* with the narrow board that is the cover's spine (Fig. 34). Smooth the endpaper in place.

Tip: It's important for the text block spine to line up with the rear edge of the front cover's board. If they're "off," then the text block won't be aligned properly inside the cover.

28. Now paste the unused half of the back endpaper. To line it up perfectly, simply close the book (Fig. 35).

Then open the book and check if any little adjustment is necessary. Make the adjustments and smooth out the paper.

29. Wrap waxed paper all around the outside of the book, from the inside of the front cover to the inside of the back cover. Allow the book to dry under pressure, using a book press or a large weight.

Note: When designing your own book, you're not limited by the project's measurements. The size of a book is determined by its text block. Choose whatever size you wish for the text, remembering that each sheet must be folded in half to make the pages. Make enough signatures for the desired thickness. The cover should be slightly larger than the text block, either 1/8" (3 mm) or 1/4" (6 mm) at the head, tail, and fore edge. This overhang covers any slight variations in the text block. Measure and cut the cover boards to allow for the overhang on three sides; make the spine board precisely the width of the text spine.

Fig. 34

Fig. 35

Fig. 36

Fig. 37

ENDPAPER VARIATIONS

It's possible to attach the text block without using any endpapers. Simply paste the first page to the inside front cover, again being careful to align the text spine with the cover's rear edge. Then paste the last page to the inside back cover.

If you like endpapers, there's no reason to stop at one set. Some very fine books have three sets of endpapers. You'll need two pieces each of three decorative papers, each piece twice the width of the text block. Paste one endpaper onto the first page; then paste the second endpaper onto the first. Repeat for the third endpaper, pasting it in turn onto the front cover. Remember to align the last endpaper perfectly with the edge of the cover board. Now repeat the whole process at the back. The newly created pages are called *fly leaves*.

Rather than being used for endpapers, decorative papers can be applied to the edges of the text pages to create visual interest. Be careful about what you choose for edging; it thickens the fore edge of the text pages and might interfere with the book closing properly.

COVER CORNER VARIATIONS

The choice of corner to make depends upon the desired appearance for the book and the type of paper or fabric used. The universal corner is good for fabric and soft or thin papers. For heavy, heavily textured, or hard-surfaced papers, a mitered corner is better. (Gift wrapping paper is a good example of a hard-surfaced paper; some is even glazed.)

Mitered Corners

This type of corner requires some cutting. Lay the board pieces onto the paper, and precisely mark their outlines. (The spine outline is optional.) Now cut straight up and straight down from the outer edges of the cover boards (Fig. 36).

Before mitering the side cuts, cut straight out from the board a distance equal to the board's thickness. Then make a 45-degree cut (Fig. 37).

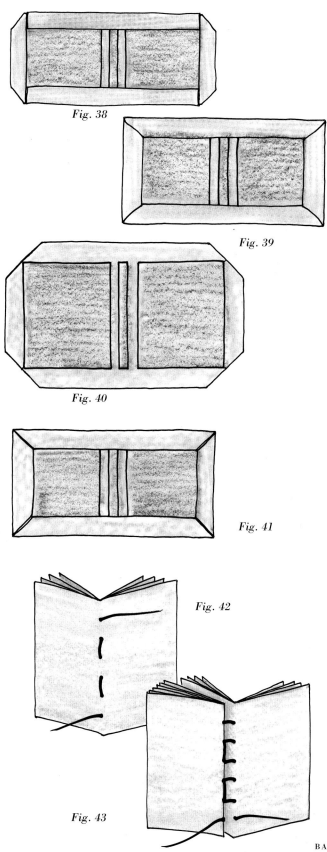

Fig. 38

Fig. 39

Fig. 40

Fig. 41

Fig. 42

Fig. 43

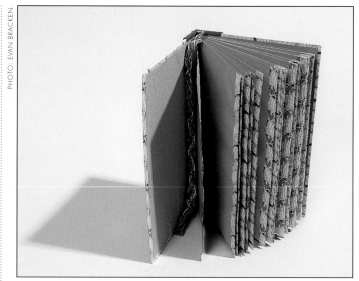

Untitled journal, Dorothy Swendeman.

Now paste the top and bottom strips onto the boards, pressing them down firmly to get good clean edges (Fig. 38). Finally, paste the side portions onto the boards (Fig. 39). Notice how that tiny straight cut allows the paper to wrap up the edge of the board before it miters. If you make a 45-degree cut directly from the edge, the board will peek through at the corner.

Another Mitered Corner

If you are capable of making perfect cuts, this corner meets itself exactly, with no overlaps. Therefore, it's great for very heavy or heavily textured papers where any overlap would be too bulky.

Measure half the thickness of the board and mark it at each corner. Using a triangle to ensure perfect angles, draw and cut 45-degree angles from those measurements. Then cut a split toward each corner (Fig. 40).

Paste each portion to the boards, pressing firmly to ensure clean edges (Fig. 41). The angles should match up perfectly, with no board showing and no overlap.

STITCH OR SIZE VARIATIONS

If the book is larger, more holes and stitches are necessary to hold the pages together firmly (Fig. 42). Always use an even number of holes. Simply mark and poke more holes in the spine; then continue the stitching pattern as you did with the project (Fig. 43). The stitch remains the same, regardless of the size of the book.

COVER DECORATION

Adding strips or bands of contrasting paper is one simple embellishment. Figure 44 shows the addition of strips of paper across the entire book. Cut pieces of one or more papers into long bands of whatever width is desired. After the cover is finished, but before the text block is pasted in, paste on the bands. Do not fold them over the edges yet.

After all the bands have been pasted, close the cover. This allows the paper to stretch over the spine while it still has some room to give rather than split. Now open the cover and paste the bands around the edges onto the inside, staggering the ends to prevent bulk (Fig. 45). Finish the book as usual.

RIBBON TIES AND BOOKMARKS

Ribbon ties and bookmarks are great fun, and they often add a special quality to the book. Select ribbons that aren't too bulky—satin or grosgrain ribbon and soft cotton tapes are good.

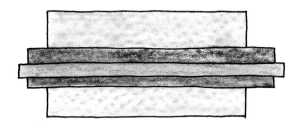

Fig. 44

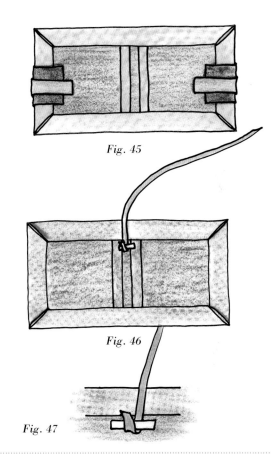

Fig. 45

Fig. 46

Fig. 47

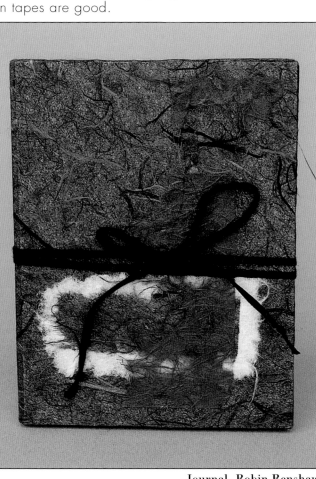

Journal, Robin Renshaw.

Bookmarks

Estimate how long a bookmark you desire. Cut the ribbon that length plus about 2" (50 mm). The additional length is the part buried under the text block, holding the bookmark in place. Also cut a small piece of scrap paper, about 3/8" x 1" (10 x 25 mm).

Paste the ribbon in place (Fig. 46), coming down the spine about 1" to 1-1/4" (25 to 32 mm). Paste the scrap paper over the ribbon. Then turn the ribbon back on itself and paste it down (Fig. 47). Turning the ribbon back on itself, over the scrap paper, really locks it in place. Then finish the book as usual.

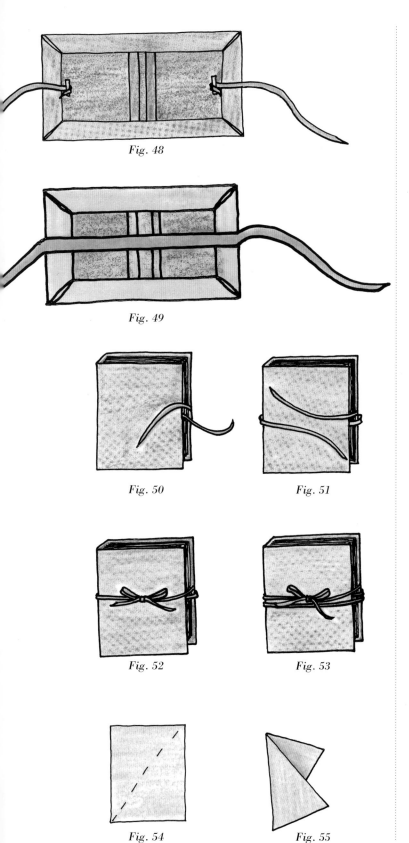

Fig. 48

Fig. 49

Fig. 50

Fig. 51

Fig. 52

Fig. 53

Fig. 54

Fig. 55

Ribbon Ties

These are measured and attached the same way you do a bookmark. The only difference is that there are two of them, and they attach to the sides (Fig. 48).

If it's a small book, the tie can be a single piece of ribbon. Add the full width of the open cover to the desired length of the ties. Then paste the ribbon across the inside of the cover (Fig. 49).

Most people get confused trying to tie a book together, especially when the ribbon wraps all the way around the book. Help remind them that the back tie must come forward and the front tie must go back, or else the book doesn't tie closed (Figs. 50–52). This is more obvious if the bow or knot is at the fore edge.

Ties are especially lovely if they wrap around the book twice. My personal taste is to have the first wrap go low, under the final bow, as if it's underlining the bow (Fig. 53).

FORMAT VARIATIONS

As with any binding technique, format dictates the final look of a book. Pages can be folded diagonally, creating interesting shapes. Covers can fold in on themselves, and envelopes can be placed inside the covers. The simple codex becomes complex with format.

Unusual Page Folds and Book Shapes

Pages don't have to be folded directly in half; there are all sorts of other options. Books with pages folded diagonally into different patterns present an interesting choice for the cover: Should it remain rectangular or echo the shape of the pages? If the cover is to be rectangular, it must be large enough to protect the entire page. The other option—cutting the cover the same shape as the pages—requires a few new techniques.

First decide on a page fold or combination of folds for your pages. (Figure 54 illustrates one type of page fold, and figure 55 shows the resulting cover shape.) Then fold all of the pages and nest them into signatures.

Trace the signature outline onto a piece of scrap paper. Enlarge the outline by 1/8" (3 mm) or 1/4" (6 mm), whichever is the desired overhang. Use the scrap paper as a pattern to measure, mark, and cut the cover boards.

Lay the board pieces on the cover paper and paste them in place (Fig. 56). Notice that the corners are not

90 degrees. That's not a problem; there are two ways to make non-90-degree corners. Both are mitered corners.

Exterior angles: Cut a split straight away from the corner (Fig. 57) and fold one side over the board (Fig. 58), but don't paste it yet. Mark the board's edge on the folded portion.

Cut along the mark, or very slightly inside the mark (Fig. 59). Then fold the other side over the board, again without applying paste. Mark a line down the center of that corner (Fig. 60).

Open out the second fold and cut straight out from the board for a distance equal to the board's thickness. Then cut along the center line (Fig. 61).

Finally, paste both sides in place (Fig. 62).

Interior angles (Fig. 63): Before the board is pasted to the cover paper, tear a small patch of the cover paper for each inward-facing angle. Also tear a split into that patch (Fig. 64).

Paste the patch onto the inside of the board. The torn split fits into the angle, creating flaps that are folded and pasted to the outside (Fig. 65).

When patches have been pasted to all of the interior angles, paste the board onto the cover paper. Then cut a split straight away from the angle (Fig. 66).

Fig. 56

Fig. 57 Fig. 58 Fig. 59

Fig. 60 Fig. 61 Fig. 62

Fig. 63 Fig. 64

Fig. 65

Fig. 66

Models, Shereen LaPlantz.

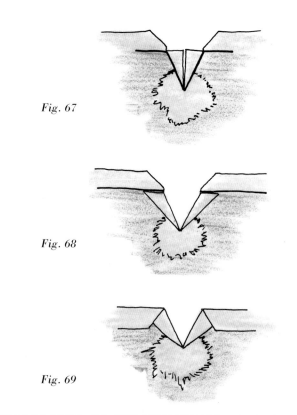

Fig. 67

Fig. 68

Fig. 69

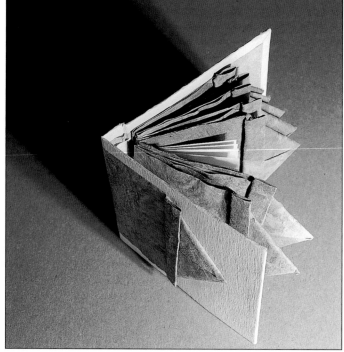

Model, Shereen LaPlantz.

Models, Shereen LaPlantz.

Notice that there are actually two more corners on this angle. They're up at the top. Follow the instructions for exterior angles and cut the cover paper for these angles now (Fig. 67).

Fold in the two small flaps near the patch and paste them in place (Fig. 68). Notice how the patch covers the exposed board.

Finish by folding down the two remaining sides and pasting them in place (Fig. 69).

Hinged Covers

Cover hinges are used to allow easier access to the pages and to add visual interest. Simply cut your cover board wherever you want to have a hinge and add a space between the two pieces (Fig. 70). The space between the two pieces of board is identical to the gap at the spine. A 1/8" (3 mm) space allows the hinge to swing 90 degrees. If more swing is desired, then the space should be about 3/16" (5 mm).

Wrap-Around Cover

One of the simplest format changes is to add an extra flap to the cover. This provides a protected place for something such as a photograph, print, or map.

When measuring and cutting the cover boards, cut a second spine (for the fore edge) and a third cover. The fore edge spine must be narrower than the real spine, or the front cover will be lifted up. Since the third cover tucks inside the front cover, it must also be narrower (Fig. 71).

Text Envelope or Wrapper

Simple envelopes can be attached to either cover, both inside and out. Simply create the envelope; then paste or stitch it in place. A text envelope or wrapper is a single sheet of paper, attached to the back cover, that is designed to wrap around the entire text. It's most commonly used when the text pages are loose rather than bound together. It can also be used if occasional loose pages are included. In many cases, wrappers are used to indicate that the pages are especially fragile or precious.

Generally wrappers are made of sturdy, sheer paper, and envelopes are made of sturdy, medium-weight paper.

The wrapper measures the size of the back cover, plus the thickness of the text block, and plus about two-thirds of the page. Cut a slight angle from the spine to the top and bottom edges of the wrapper. This allows move-

Fig. 70

Fig. 71

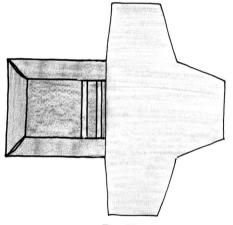

Fig. 72

Photos above: *Pregnant With Ourselves*, Shereen LaPlantz, Press de LaPlantz.

Fig. 73

Fig. 74

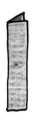

Fig. 75

Fig. 76

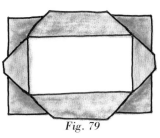

Fig. 77

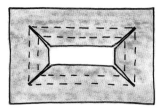

Fig. 78

(Fig. 79 illustration)

Fig. 79

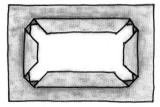

Fig. 80

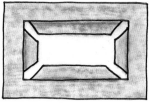

Fig. 81

ment without crushing the wrapper's edge. The remaining angles are whatever you find pleasing (Fig. 72). Paste the wrapper to the inside back cover.

When developing ideas for book structures, extend some element that interests you. I bought a book on illustrated manuscripts with loose hand-printed pages that were protected by a text wrapper. Liking the wrapper idea, I experimented with several styles of wrappers and envelopes. This process ultimately resulted in *Pregnant with Ourselves*.

Print Mats Book

This is a book that's designed to hold prints or photographs within mats. If the desired photos or prints already exist, then the mats can be sized to fit perfectly. Otherwise, select your favorite size for photos or prints and make the book accordingly. The window is cut to fit the image, and the surrounding mat makes a frame of about 2" (50 mm) all around.

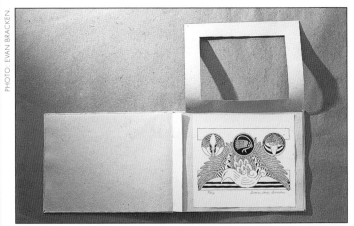

Model, Shereen LaPlantz with prints by Barbara Shaw Brinson.

Make a pattern using your measurements (Fig. 73). There are two mats per parent sheet, with a gap of about 2-1/2" (64 mm) between them to allow for binding.

Select an oversized, heavy paper, such as a printmaking paper. Cut out as many mat pairs as desired, keeping in mind that this becomes a thick book quickly.

Fold the mats along the dotted lines. One mat folds forward; the other folds to the back. Then fold the pair in half, forming matted pages (Fig. 74).

If these pairs are bound together now, the covers will automatically lift open, unable to contain pages that become thicker away from the spine. This only gets worse when the photos or prints are added.

The solution is to add *spacers*. Spacers are narrow pieces of paper that bulk up the spine or binding area so that it's equivalent in thickness to the fore edge. It's important that the thickness of the spacers equals the bulk of the mats and their prints. Spacers must go both outside and inside the spine fold of each mat. The outside spacer should be about 1/2" (13 mm) less wide than the open space between the mats and the inside spacer about 1" (25 mm) less. For a 2-1/2" (64 mm) space between mats, the outside spacer should be 2" (50 mm) wide, and the inside spacer should be 1-1/2" (38 mm) wide.

Fold all of the spacers in half lengthwise (Fig. 75). Then place one outside spacer over the spine fold of each mat (Fig. 76) and place one inside spacer inside the spine fold (Fig. 77).

One mat pair with spacers constitutes a signature. Treat these signatures as you would any others. Mark them, poke holes, and sew them together.

The only difference arises when attaching the text body (the mats) to the cover. Because there aren't any first and last pages to paste onto endpapers, you'll need to substitute the spacers. They're short, but they will work acceptably. Paste the spacers directly onto the inside covers. Then cover them with single (half-size) endpapers.

Another Type of Mat Book
This mat pleats in on itself to hold the picture in place. It isn't as sturdy as the other type of mat, so it works best with photographs or small prints. It can be made of almost any paper, including photocopier paper. Rice paper, however, is too soft. The mats may be bound into a book or left as singles. As singles, they make a quick way to mat a print or photo to send to a friend.

Select a long piece of paper that can be folded in half to become a signature. On the back, measure and mark where the photo will be placed and how big the opening will be. Mark another rectangle about 1/4" to 1/2" (6 to 13 mm) in, towards the center, from the original marked line. Measure a third line about 3/4" to 1-1/2" (19 to 38 mm) in from the second line.

Cut on the third line (Fig. 78). Then cut a split through the corners, from the center to each original line.

Fold back along the original line (Fig. 79). Now fold in, this time on the second line (Fig. 80). The four flaps hold the photograph inside their folds (Fig. 81).

A background sheet may be pasted onto the mat page, locking the photograph inside, or the mat may be left open for easy access. Bind the mats together as you did for the previous mat book. Be sure to add a spacer to the first and last signatures so that the text block can be bound to the cover.

Star Book
There are two types of star books: one that is essentially a basic codex and one that is a triple layer accordion fold book. The latter will be covered in the chapter on fold combinations.

This star book has two sets of signatures for the text block, both made of single sheets. One set provides the internal framework and is bound together with spacers, as you would make a standard codex. The other set of signatures attaches to the first at the fore edge to make the star formation. One important difference between the basic codex and the star book is the spine. This spine is not made with a board; it must be able to compress, allowing the pages to radiate into a star.

Photocopier paper works fine for the text, but the spacers require something heavier, such as watercolor or charcoal paper. Often, two different papers are chosen for the text—one for the hidden pages and another for those that form the star.

For ease of instructions, page sizes and numbers are suggested here; when making your own star books, feel free to vary them however you please. Start by selecting two different photocopier papers for the text. Cut five pieces in half for the pages that form the star and cut four in half for those that are hidden. Then trim the eight "hidden" halves so that they are 2" (50 mm) shorter (along the longer dimension) than the others. Fold all eight of the shorter pieces into quartos to make one set of signatures; then fold nine of the longer pieces to make the other set. (The tenth longer sheet is an extra.)

Cut nine spacers 2" (50 mm) wide from the heavier paper. These should be identical in length to your folded signatures. Fold each of them in half.

Note: No matter what size and number of pages used, one set of pages must be shorter than the other. The width of the spacer is equal to the difference in length between the two.

Nest one of the larger pages in each spacer (Fig. 82), making nine signatures. Then sew them together, just as you would for any basic codex (Fig. 83).

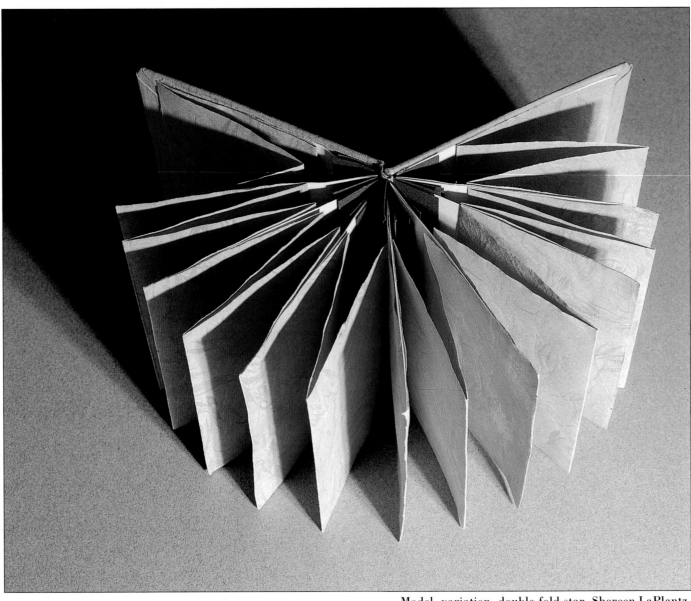

Model, variation, double-fold star, Shereen LaPlantz.

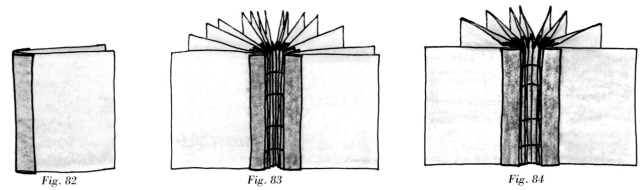

Fig. 82 *Fig. 83* *Fig. 84*

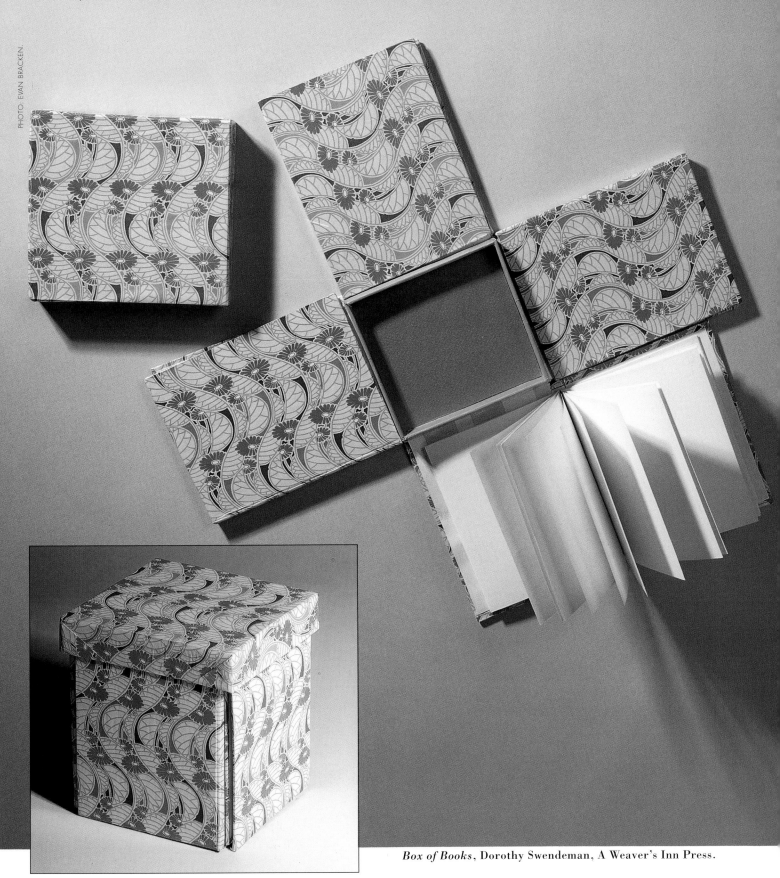

Box of Books, Dorothy Swendeman, A Weaver's Inn Press.

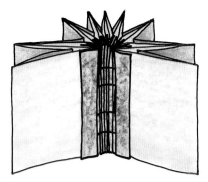

Fig. 85

Fig. 86

PHOTO: EVAN BRACKEN.

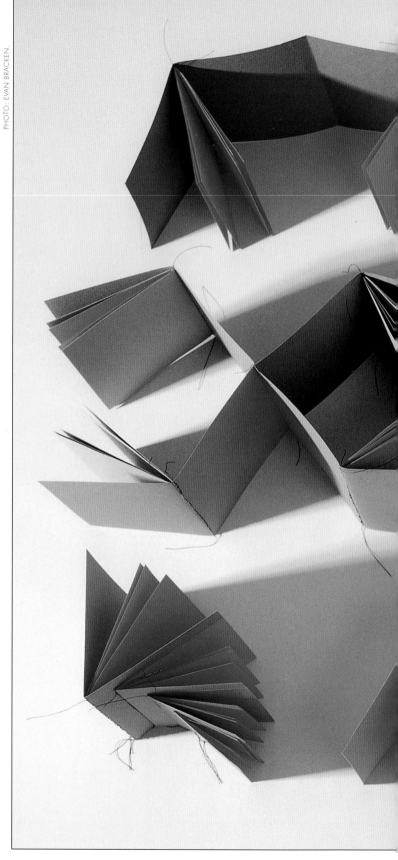

Now the two pages of each signature must be pasted together into pairs. Paste them together at the fore edge only, leaving the spacers exposed, *not* trapped inside the pasted pairs (Fig. 84).

The smaller pages go in between the pasted pairs, one page between each pair. Paste the smaller pages to the adjacent pairs at the fore edge. The fold on each smaller page should just reach the edge of a spacer (Fig. 85).

The cover is the same as any other cover, except that there is no spine board. Leave the appropriate amount of space for a spine, but don't include the board (Fig. 86). Attach the text block by pasting the first and last pages to the inside covers.

Other Formats

The basic codex is perhaps more open to format enhancement than any other bookbinding technique. The pages may be made in a centerfold, gatefold, or even accordion fold, and the covers can be changed any number of ways. There are so many possible variations that the distinction between a basic codex and a fold combination book becomes blurred.

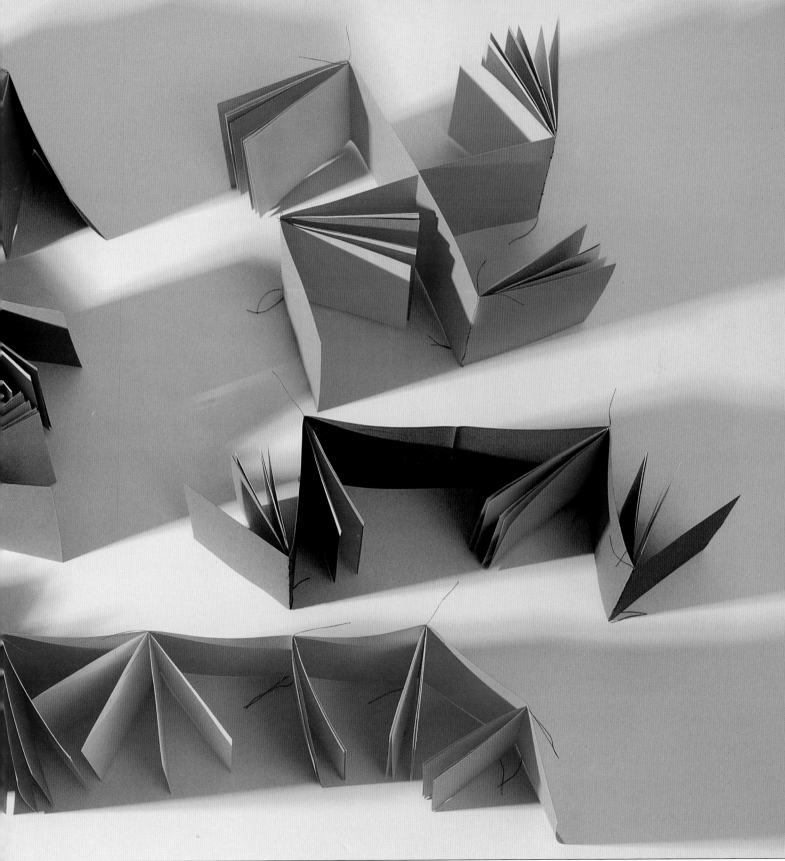

Format models, Shereen LaPlantz.

STITCHES

THERE ARE MANY STITCHES for holding signatures together. One approach, which is the traditional method for fine binding still used today, is to stitch over tapes. These tapes are then either embedded into the inside covers or displayed on the outsides of the covers.

Another variation with sewn signatures is to let the stitches show. This can be accomplished by exposing the signatures at the spine or by stitching through the cover at the spine. When you plan to make the stitches visible, choose a thread in a contrasting color, or at the least, use thread that is thick enough to highlight the stitch.

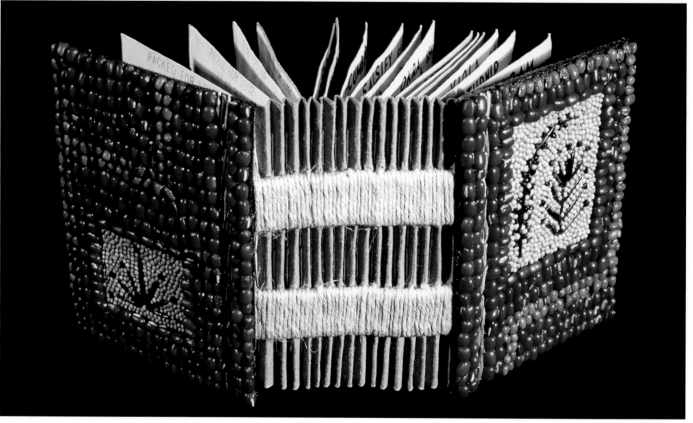

Plant This Book, Carol Barton.

PROJECT

In this example, eight signatures are sewn over tapes. The signatures are exposed at the spine, and the tapes are fastened to the outsides of the covers.

Materials

Text: 16 sheets of standard-sized photocopier, laser printer, or typing paper, each cut in half and folded into quartos

Endpapers: 2 pieces of marbled or other decorative paper, cut to size as described below

Cover boards: 2 pieces of any suitable cover board (see page 12), cut as instructed below

Cover paper: 2 pieces of rice paper, medium- or light-weight handmade paper, silk threads paper, or gift wrapping paper, cut to size as described below

Tapes: 3 pieces of any stiff ribbon, 1/2" to 3/4" (13 to 19 mm) wide and about 10" (254 mm) long

Thread: About 1-1/3 to 1-2/3 yds. (1.3 to 1.5 m) of crochet, beading, or other strong, decorative sewing thread

Adhesive: PVA or YES paste

Scrap paper for pasting

Waxed paper

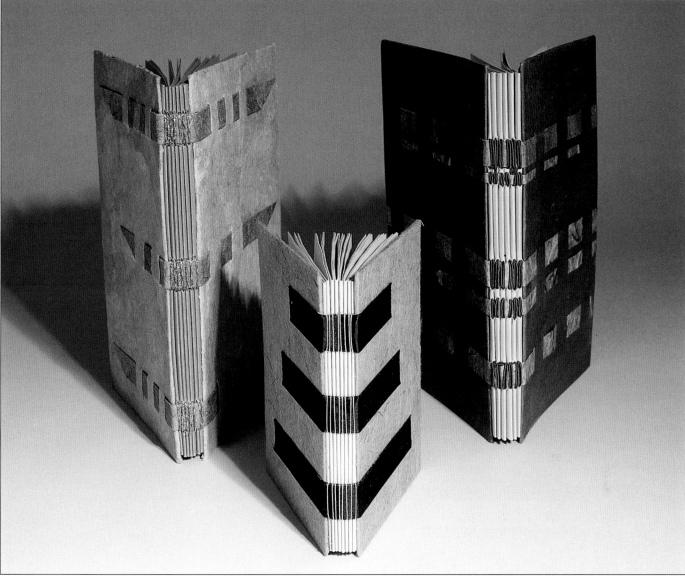

Project models, left and center, Shereen LaPlantz; right, Dorothy Swendeman.

Tools

#24 tapestry needle or other large-eyed, blunt-ended
 needle
Tea towel or paper towel folded into quarters lengthwise
Pencil
Push pin, awl, or equivalent
Beeswax
Book press or large, heavy weight

Process

1. Measure and cut each cover board 1/8" (3 mm) larger than the text pages on three sides: head, tail, and fore edge. Then measure and cut each sheet of cover paper 2" (50 mm) wider and 2" longer than the cover board. (This allows plenty of extra paper to fold over on each edge.)

2. Cut the endpapers slightly smaller than the cover boards. When the endpapers are pasted inside the cover boards, there should be a 1/4" (6 mm) frame showing all around.

3. Paste one piece of cover paper onto one board. Make the corners and fold the extra paper onto the back. Then apply the endpaper (Fig. 1). Repeat with the other board. Now wrap both covers in waxed paper and dry them under a heavy weight.

Fig. 1

Fig. 2 Fig. 3

Fig. 4

Fig. 5

4. Nest the text pages into eight signatures of four sheets each (Fig. 2) and mark the hole positions in each signature (Fig. 3). The holes *must* match up with the tapes; the holes are positioned *exactly* on each side of the tapes, with no extra space. Once the marks are perfect, poke the holes.

5. The sewing can start either on the outside or on the inside of the first signature. The outside is used here for ease of illustration, but that means the knot will be on the outside and will show. Starting on the inside will place the knot on the inside, where it won't show. Sew into the signature at the second hole (Fig. 4).

6. Sew out of the top hole, then back down, over the tape, into the second hole (Fig. 5). Tie off the knot, either inside or outside, wherever the two ends meet. Then continue sewing, all the way to the bottom hole, using a running stitch over the tapes (Fig. 6).

7. After sewing back out the second hole from the bottom (Fig. 7), add on the next signature. Sew into its second hole from the bottom (Fig. 8).

8. Sew down to the bottom hole. Then sew a running stitch up the spine (Fig. 9). Obviously, the point is to sew *over* the tapes and *inside* the signatures. It also helps to keep the two signatures as close together as comfortably possible.
Keep the thread pulled tightly as you sew, pulling *only* in the direction of the sewing. If you pull against the sewing, you may tear the signature.

9. Sew back out the second hole from the top (Fig. 10) and add the next signature. Sew into its second hole from the top. Then sew out of the top hole and do a running stitch down the spine (Fig. 11).

10. Continue for all eight signatures (Fig. 12). Then tie off the end of the thread with a couple of half-hitch knots (Fig. 24, page 37). Adjust the tension if necessary by gently pulling the tapes (Fig. 13), but don't pull the tapes out altogether.

11. Attach the covers to the text block by pasting the tapes onto the outer surfaces of the covers (Fig. 14). Position the covers and trim the tapes to whatever lengths desired. Carefully paste the tapes in place. (Either of the recommended adhesives will show if any gets on the surface, so use care when applying.)

12. Wrap the finished book in wax paper and dry it under weight.

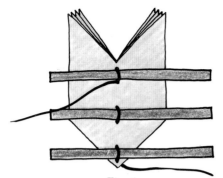

Fig. 6

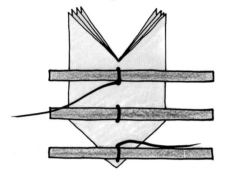

Fig. 7

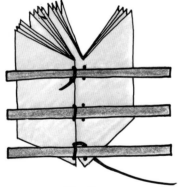

Fig. 8

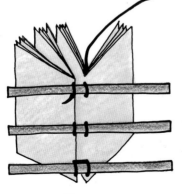

Fig. 9

Fig. 10

Fig. 11

Fig. 12

Fig. 13

Fig. 14

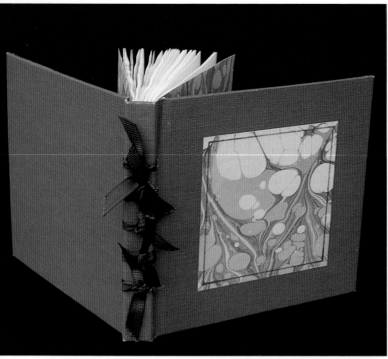

PULLING THE TAPES OUTSIDE A SPINE BOARD

When the tapes are threaded through the opening between the spine board and the cover boards, they can be tied decoratively on the outside.

Sew the signatures together as described in the project. Then measure the spine to determine the size of the spine board.

After cutting boards for the front, back, and spine, arrange them on the cover paper with a 1/8" (3 mm) gap on either side of the spine (Fig. 15).

Paste the cover paper to the boards as usual. Then cut a single endpaper to paste onto the entire inside surface of the cover (Fig. 16).

Carefully make slits into the groove on each side of the cover's spine. The slits must match the width and location of the tapes exactly. Thread the tapes through the slits (Fig. 17) and tie the tapes into knots across the spine (Fig. 18).

Journal, anonymous book from Japan.
Collection of Dolores Guffey.

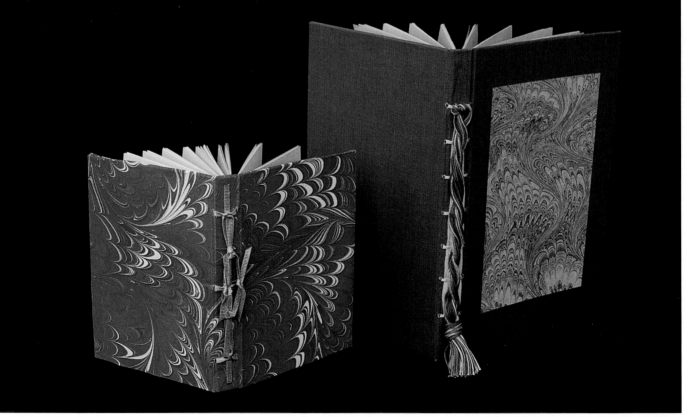

Untitled journals, Dolores Guffey.

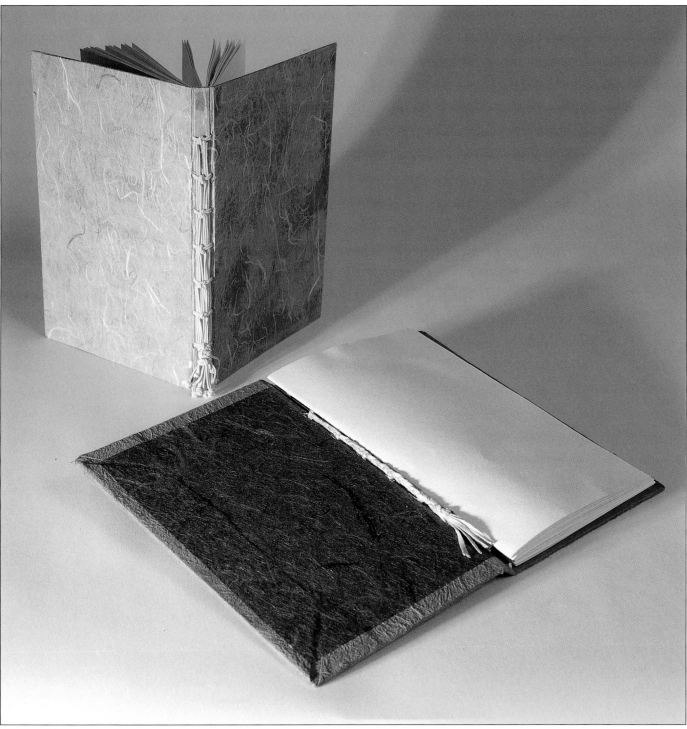

Models, standing: Shereen LaPlantz; open: Dorothy Swendeman.

What can you do with the ends after the knots are tied? One possibility is to thread the ends down under the other knots, making a tassel at the tail. On her rust-colored journal, Dolores Guffey made a decorative spin braid of crochet thread to place over the tape. For her blue journal she created an intricate knotting pattern to incorporate the loose ends. Dorothy Swendeman threaded the ends back inside her journal, then braided them together.

Fig. 15

Fig. 16

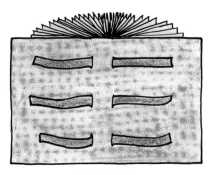

Fig. 17

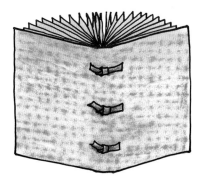

Fig. 18

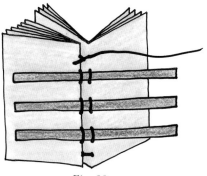

Fig. 19

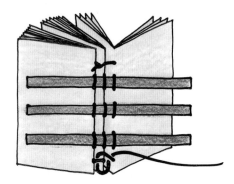

Fig. 20

Fig. 21 *Fig. 22*

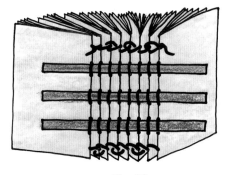

Fig. 23

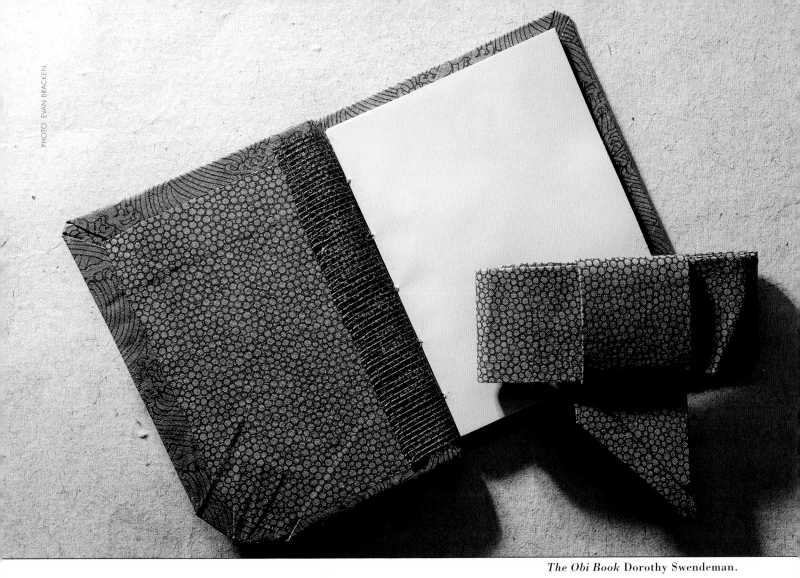

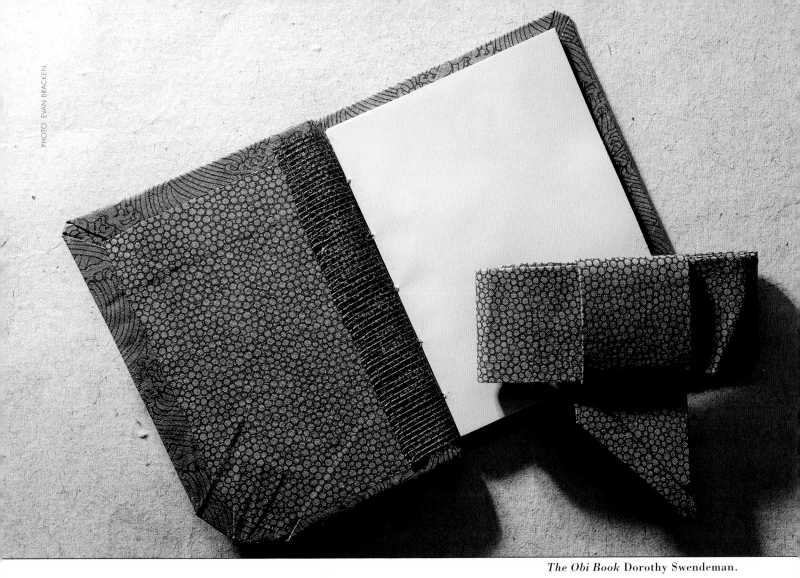

The Obi Book Dorothy Swendeman.

THE KETTLE STITCH

Traditionally there are two more holes poked into the signatures, one at the head and the other at the tail. When sewing over the tapes, the head and tail are connected with a kettle stitch to make a stronger attachment.

Prepare everything just as you did for the project, but make an extra hole, head and tail, for each signature. Sew into the first hole, and make a running stitch down the first signature. Sew out of the bottom hole and into the tail of the second signature. After sewing up the spine, come out of the top hole and tie a knot with the loose end on the first signature (Fig. 19). Then sew into the head of the third signature and continue down.

At the tail of the third signature, the kettle stitch begins. The thread goes through the stitch connecting the first two signatures, then under itself and into the bottom hole of the fourth signature (Figs. 20 and 21).

Continue sewing up the fourth signature and make another kettle stitch. At the head, the kettle stitch goes through the adjacent stitch from below, then under itself and into the next signature (Fig. 22).

Continue adding the rest of the signatures. Sew a running stitch over the tapes and a kettle stitch at the head and tail (Fig. 23).

USING A SEWING FRAME

It's rather difficult to keep the tension tight and even while juggling multiple signatures and tapes. A sewing frame makes this process much easier. A traditional tool for fine hand binding, a sewing frame consists of a large, flat board for the bottom, with a U-shaped frame

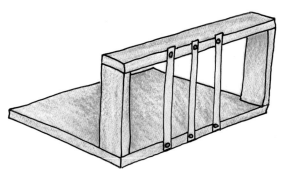

Fig. 24

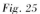

Fig. 25

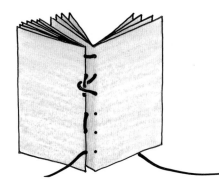

Fig. 26

Fig. 27 *Fig. 28*

attached along one side (Fig. 24). The signatures lie flat on the board during the sewing, and the tapes are thumbtacked to the frame.

If your desire is to work traditionally, then the tapes should be attached inside the covers. Make a regular cover with front, back, and spine boards. Cover it with a lovely paper or fabric, but don't attach the endpapers. Position the text block and paste the tapes to the inside covers, inlaying them if they are bulky. Finish by covering the tapes with the endpapers.

Tip: When using very heavy text paper it's difficult to get the signatures close together, even with a sewing frame. You can obtain more control by sewing over the tapes and through a coarse fabric. *Super*, which is a thin, stiff mesh that has an open weave similar to cheesecloth, is ideal for this purpose. Used in most traditional binding, super can be purchased from bookbinding supply houses. Coarse buckram, or a similar substitute, is available in fabric stores.

Normally an inch or so (about 25 mm) of super extends on both sides of the spine, providing a means for attaching the text block to the cover. In *The Obi Book* Dorothy Swendeman used super to attach the text to the cover but left it exposed.

If you're interested in more of the details of making traditional fine bindings, there are a number of sources available. (See the bibliography.)

STITCH VARIATIONS

French Stitch

The French stitch is both lovely and quite flexible. Perhaps it is too flexible. Unless the book requires a spine that is elastic, this stitch needs to be controlled by a kettle stitch at head and tail or, as Bonnie Stahlecker did in *The Range of Predictability*, with tapes and the kettle stitch.

Prepare the signatures as for any book. This stitch can be used with any number of signatures, but I think it is prettier and less stretchy when worked in groups of three. Mark and poke an even number of holes in each signature. Then sew a running stitch up the first signature (Fig. 25).

Connect the next signature by sewing into the top hole. Then make a detour with the running stitch and sew under the neighboring stitch (Figs. 26 and 27). When

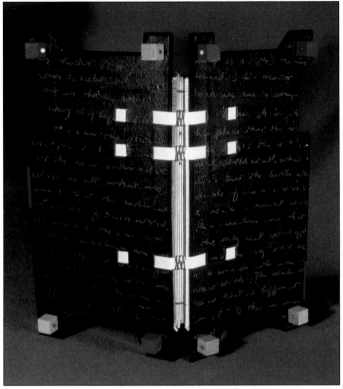

The Range of Predictability, Bonnie Stahlecker.

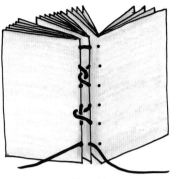

Fig. 29

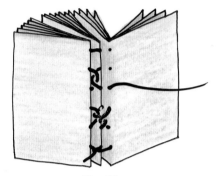

Fig. 30

the tension adjusts, the stitch will become even (Fig. 28). Continue this process down the entire signature (Fig. 29); then tie off the ends.

Connect the third signature at the tail and start upward with the running stitch. Again make the detour and sew under the neighboring stitch (Figs. 30 and 31). Again the tension will adjust naturally (Fig. 32). Continue this detouring up the spine.

The fourth signature starts the process over again. Connect at the head and sew a running stitch down the spine (Fig. 33), adding more signatures and repeating the detours.

Chain Stitch

This version of the chain stitch looks a bit like a crochet chain going horizontally across the spine. Because it requires extra work and offers few, if any, benefits other than beauty, it's best to use this stitch in a book with an exposed spine. Additionally, use a thread that really sets off the stitch—something thick or heavy.

Prepare two separate covers, front and back, with end-papers attached to the inside, just as you did for the project (Fig. 34).

Fig. 31

Fig. 32

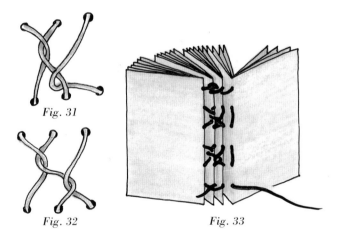

Fig. 33

Fig. 34

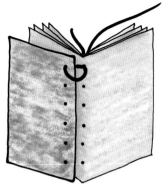

Fig. 35

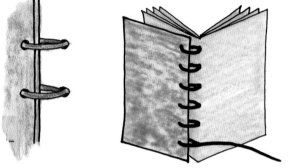

Fig. 36

Fig. 37

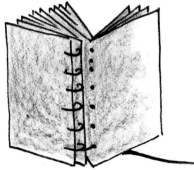

Fig. 38

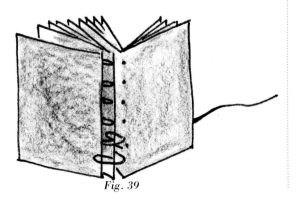

Fig. 39

Prepare any number of signatures. Then mark and poke holes in the signatures; the number of holes can be either odd or even. Mark and poke corresponding holes in the covers, placing them about 1/4" (6 mm) in from the spine edge.

Start sewing inside the signature. Sew out of the top hole of the signature, through the top hole of the back cover, and back into the top hole of the signature (Fig. 35). Tie off the end inside the signature. Then stitch down to the next hole.

Repeat, sewing a circle into the cover and back into the signature (Fig. 36). Continue this process down the signature (Fig. 37).

At the bottom stitch, don't sew back into the first signature; instead, sew into the new signature (Fig. 38).

Sew up to the next hole. Then, rather than sewing through the cover, sew completely under the adjacent stitch in the first signature and return to the current signature (Fig. 39).

Repeat, sewing up to the next hole and under the adjacent stitch (Fig. 40). Continue this process up the signature, keeping in mind that the last stitch must connect to the next signature (Fig. 41).

Repeat, adding a signature and sewing under the previous stitches, until only one signature remains to be attached.

The last signature must connect to the front cover as well as to the previous stitches. Sew under the previous stitch. Then, as part of the same stitch, sew through the cover from the inside to the outside. Sew into the last signature, placing the needle so that the thread crosses under itself (Fig. 42).

Continue up or down the signature and tie off the last stitch inside the signature.

Long or Running Stitch

In its simplest form, this stitch makes a series of long parallel lines running down the spine of a book. The threads are exposed on the outside of the spine and, if desired, can be manipulated into patterns by seizing (binding), weaving, and other techniques.

The stitching is done through the spine and signatures, and the perforations severely weaken both the paper and board. If a horizontal slit is made in place of individual holes, then the stitches have a tendency to wander; nothing is holding them in place.

Because of the need to maintain the cover's integrity, you should select your materials with care when using the long stitch. My preference is to use buckram covered with fabric.

Buckram is a very stiff material that comes in several weights, and it's impregnated with a glue that is activated with water. If several layers are glued together in the manner of plywood (placing alternate layers on the lengthwise grain and on the bias) the combination becomes exceptionally stiff, similar to mat board. When making buckram plywood, I prefer to mix the weights.

Fabric can be adhered to the buckram by wetting both thoroughly. If you want to use buckram for the boards and cover them with fabric, then form the fabric around the edges while they're both wet. Don't cut the fabric for the corners; it might fray. Use a universal corner instead (see page 38). If there isn't time to let the buckram and fabric dry naturally, do not use an iron directly on them. Lay waxed paper over the wet buckram and iron it dry gently. The glue in the buckram adds a thick coat to an iron.

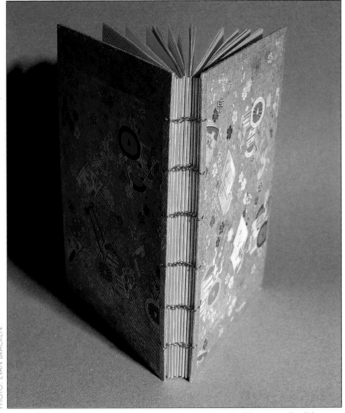

PHOTO: EVAN BRACKEN

Model, Shereen LaPlantz.

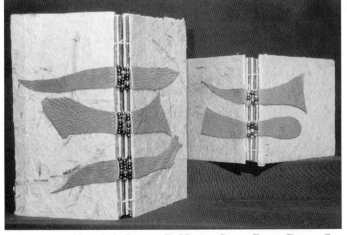

Untitled, Denise DeMarie, Grass Roots Paper Co.

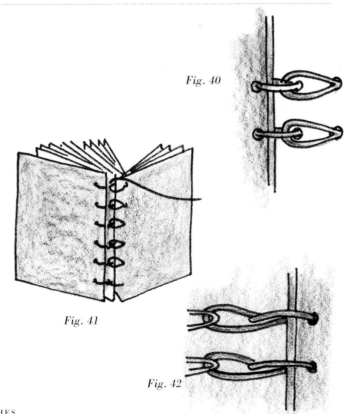

Fig. 40

Fig. 41

Fig. 42

All of this has been said about buckram because a buckram and fabric cover works beautifully with the long stitch. Wherever the stitch is sewn, it stays. Stitches don't move in fabric, and fabric doesn't weaken as much as paper does when it's perforated with stitches.

Start by making the signatures. Then prepare a buckram and fabric cover to fit.

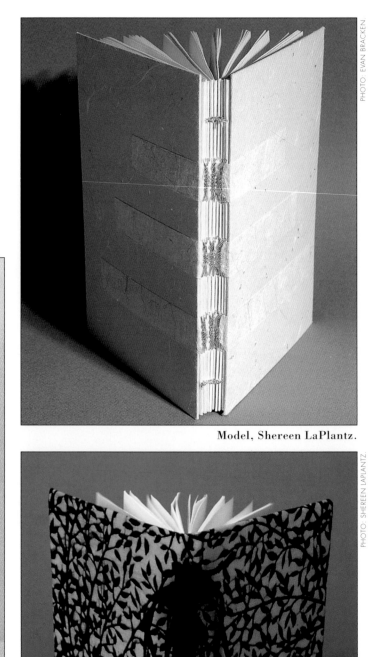

Model, Shereen LaPlantz.

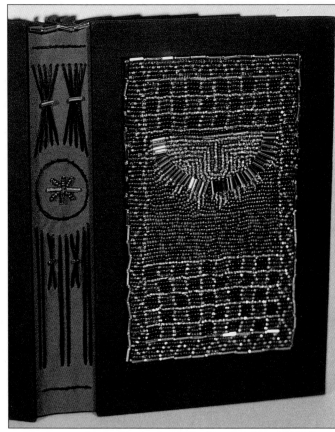

In the Beginning, Elsi Vassdal Ellis, EVE Press.

Journal, Robin Renshaw.

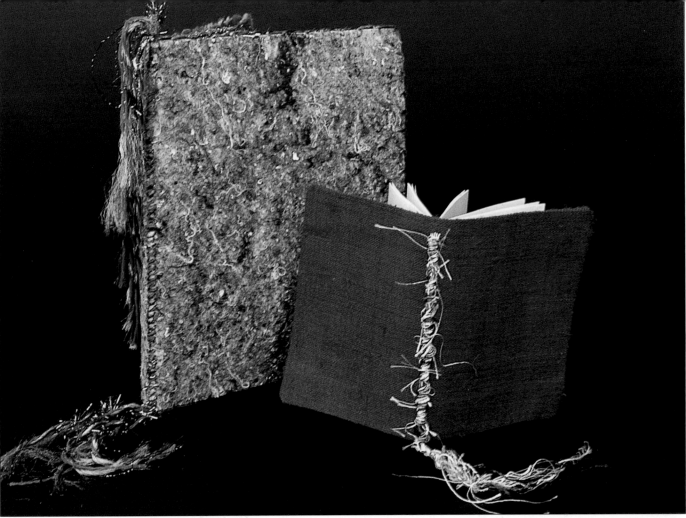

Journals, Elaine S. Benjamin.

Measure the spine, and prepunch an even number of holes through the buckram/fabric with an awl, making one set of holes for each signature (Fig. 43). It's possible to sew directly through the fabric, but prepunched holes allow a straighter line.

With a lovely thread or ribbon, sew a running stitch through the first signature and the fabric cover. Start at the bottom hole, and sew from the outside (Fig. 44). Now add the next signature. Connect it to the first one by sewing into the top hole, through the fabric cover (Figs. 45 and 46).

Alternatively, the kettle stitch works just as well as the illustrated stitch at the head and tail.

Continue adding each signature and sewing a running stitch through both the signature and the cover until done. Tie off the end at the tail (Fig. 47).

Tip: Keep checking the spine width as you add signatures. If the signatures don't sew in as expected,

the spine width may be affected. Since the cover is already finished, the spine must be very close to the prejudged width. Otherwise the covers won't lie properly. If necessary, a signature can be left off or an extra one added.

Wrapped Long or Running Stitch

One of the easiest variations on the long stitch is to wrap it while sewing. Prepare the cover as you did for the long stitch. The total number of signatures should be a multiple of three.

Sew in the first two signatures just as before. When sewing the third signature, detour. At the first opportunity, sew under the two existing long stitches (Fig. 48). Continue to wrap around the two stitches until they are completely wrapped (Figs. 49–52). Then sew up to the next hole and repeat (Figs. 53 and 54).

Continue, in groups of three signatures, until the entire book is done.

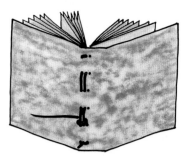

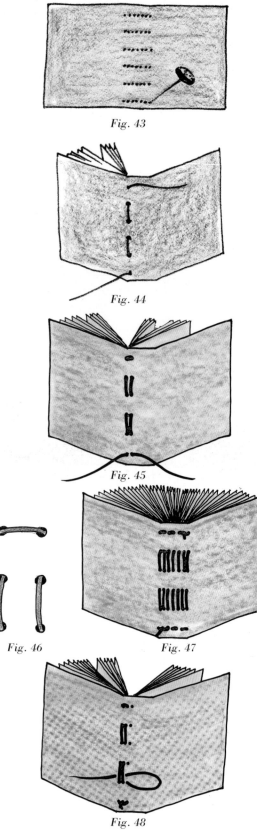

Fig. 43

Fig. 44

Fig. 45

Fig. 49

Fig. 50

Fig. 51

Fig. 52

Fig. 46

Fig. 47

Fig. 53

Fig. 48

Fig. 54

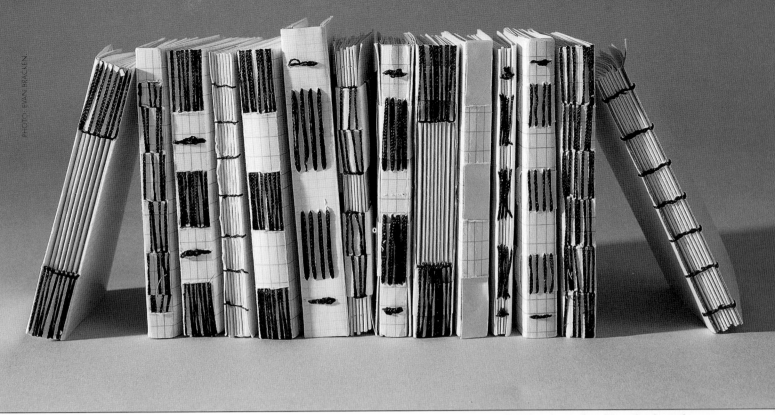

Stitching samples, Dorothy Swendeman.

Other Wrapped or Seized Stitches

Another variation is to wrap the stitches completely, forming a long cord. Any type of long, exposed stitch can be wrapped using this method. Using an exotic eyelash yarn, Elaine Benjamin completely covered a long stitch binding and a pamphlet stitch on two journals.

Double Long or Running Stitch

This is particularly good for attaching a signature to an odd binding or making a quick model. Just do a running stitch up the spine. Then turn around and do it back down the spine. It makes a solid line of stitching that's very secure. As shown in Robin Renshaw's journal, the effect can be quite lovely.

Other Possibilities

There are hundreds of stitches that can be used for bookbinding. If this area interests you, read some embroidery books and improvise. The stitches are as effective on books as they are on fabric.

Remember also that a sewing machine makes a quick stitch for binding. Many of the format models were sewn on the sewing machine. It's a fast way to see ideas or to make numbers of gift cards and books.

Stitching samples, Shereen LaPlantz.

STAB BINDINGS

JAPANESE STAB BINDINGS have a rich, formal tradition that has developed over hundreds of years. In traditional stab-bound books, the text pages are made of thin rice paper; each sheet is printed on one side, and it's folded in half at the fore edge to give strength to the page and to keep the ink from soaking through. Front and back covers are attached to the text by decorative stitching at the spine.

The concept behind stab bindings is to sew around the outside edge at every opportunity, even if it's at the head or tail rather than at the spine. In fact, you must sew into each hole two or more times to complete the pattern on both the front and back covers. To prevent the knot from being obtrusive, all stab binding stitches are begun somewhere other than at the first or last hole.

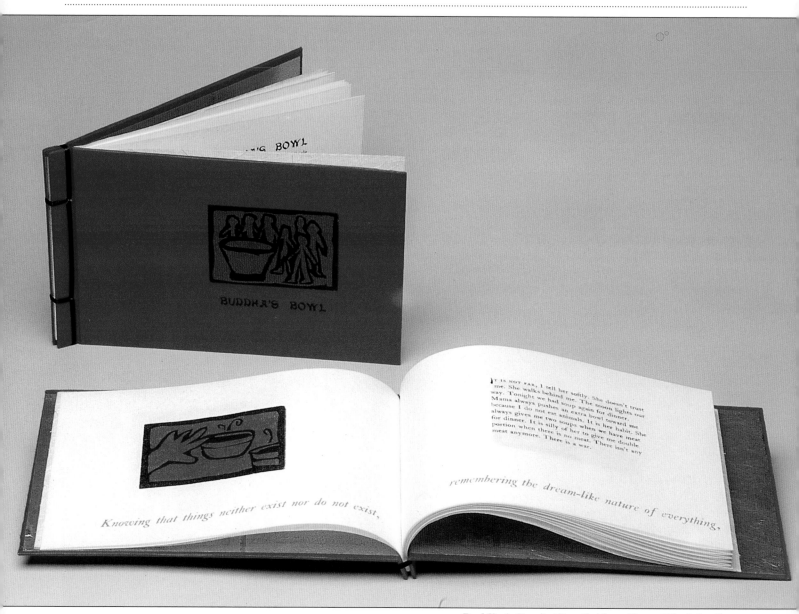

Buddha's Bowl, Alisa Golden, Never Mind the Press.

Project model, Shereen LaPlantz.

PROJECT

This book is a traditional Japanese style. It uses a simple stitch pattern that leads to several variations. Traditionally the pages are folded at the fore edge, and that is recommended for this project. The cover may be either soft or hard (covered board). The illustrations show a hard cover, but making a soft cover is an easy variation.

Materials

Text: 15 sheets of any standard-sized photocopier, laser printer, or typing paper, all cut in half lengthwise

Endpapers: 2 pieces of any marbled or decorative paper, cut as described below

Cover boards: 3 pieces of 4-ply museum board or other board that isn't too heavy, cut to size as described below

Cover paper: 2 pieces of fairly plain rice paper, lightweight watercolor paper, or charcoal paper, cut as described below

Thread: 1-1/3 yds. (1.2 m) of metallic sewing thread, waxed linen thread, or other very strong string or ribbon

Paste

Scrap paper for pasting

Waxed paper

Tools

2 C-clamps or other clamps

#18 tapestry needle or other large-eyed, blunt-ended needle

Hole punch, awl, or drill press

Pencil

Ruler

Book press or large, heavy weight

Process

1. Start by folding each cut sheet of paper in half to make the text pages (Fig. 1). The fold is at the fore edge, making pages that are shorter than they are wide.

Fig. 1

Fig. 2

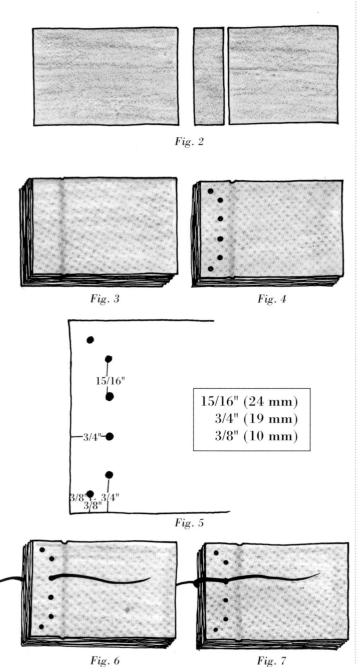

Fig. 3

Fig. 4

15/16"

3/4"

3/8" 3/4"
 3/8"

15/16" (24 mm)
3/4" (19 mm)
3/8" (10 mm)

Fig. 5

Fig. 6

Fig. 7

2. The back cover is a single piece of board cut the same size as the text pages. The front cover must be hinged so that it will open and allow easy access to the text pages. Therefore, cut two pieces of board for the front, both the same height as the back cover. (For stab bindings, the covers are cut the same size as the text block because that makes drilling the holes easier.) The hinge piece is 1" (25 mm) wide, and the width of the other front piece is equal to the width of the back cover, minus the hinge, and minus a 1/8" (3 mm) gap (Fig. 2).

3. Cut two sheets of cover paper so that each one is 2" (50 mm) taller and wider than the back cover board. Then cut the endpapers so that each is 1/2" (13 mm) shorter and narrower than the back cover.

4. Paste the two front cover boards onto one piece of cover paper, allowing a 1/8" (3 mm) gap between them. If this book will receive a lot of use, reinforce the hinge with a piece of linen tape or even bookbinder's paper tape before pasting on the cover paper. Cut a piece of tape the full length of the hinge, and apply it over the gap, on the front. (The front takes the most abuse.) Linen and paper tapes are generally available at art supply stores.

5. Finish covering the front and back boards as you would for any other cover. After applying the endpapers, wrap both covers in waxed paper and dry them under weight.

6. Make a stack of the text pages and position them between the front and back covers (Fig. 3). Then hold the stack together with clamps. If the clamps might mar the covers, place a folded piece of paper toweling inside each jaw.

7. Mark the positions for the holes (Figs. 4 and 5). Then make the holes through the entire book with a drill, awl, or punch.

8. To begin this stitch, sew through the third hole from back to front, letting the tail end of the thread hang loose (Fig. 6). Then sew completely around the spine and back through the same hole (Fig. 7). The sewing end will be on the front again.

9. Sew into the fourth hole (Fig. 8). Again, sew completely around the spine and back through the same hole (Fig. 9). This time the thread will be on the back.

10. Repeat the process with the fifth hole (Figs. 10 and 11). Now sew into the next hole; it's the one closest to the corner (Fig. 12). Sew around the spine and back into the same hole (Fig. 13).

11. Now sew completely around the tail and back into the same hole (Fig. 14).

12. Going back up the spine, sew into the fifth hole (Fig. 15). Sew around the tail and back into the same hole (Fig. 16).

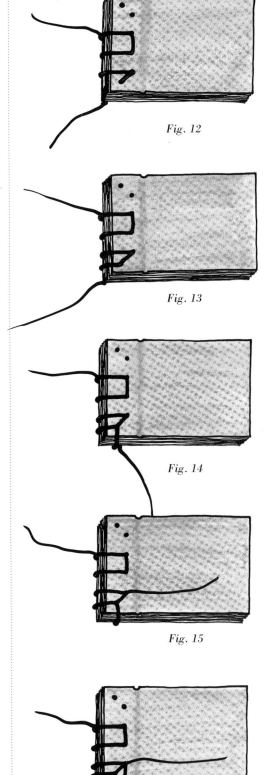

Fig. 12

Fig. 13

Fig. 14

Fig. 15

Fig. 16

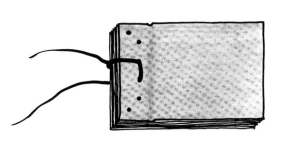

Fig. 8

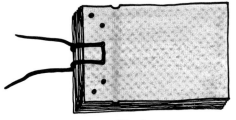

Fig. 9

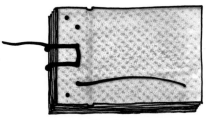

Fig. 10

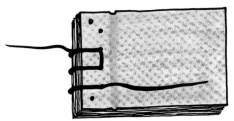

Fig. 11

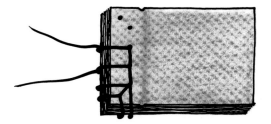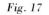

Fig. 17

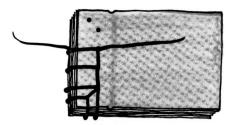

Fig. 18

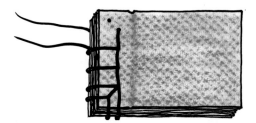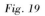

Fig. 19

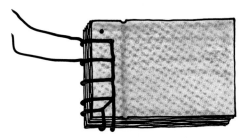

Fig. 20

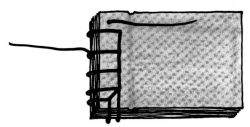

Fig. 21

13. Now sew into the next hole (Fig. 17). There is already a stitch around the edge, so make a running stitch into the next hole (Fig. 18). The same is true here, so continue the running stitch up to the second hole (Fig. 19).

14. Finally, here is an empty edge. Sew completely around the spine and back into the same hole (Fig. 20).

15. Sew into the first hole (Fig. 21), wrapping completely around the spine and back into the same hole (Fig. 22).

16. Remember, the idea is to sew around every available edge. Sew around the head and back into the same hole (Fig. 23).

17. Sew into the next hole (Fig. 24); then wrap around the head and go back into the same hole (Fig. 25). This is the final stitch. Tie the ends into a knot and trim off the excess. Just for your information, these ends traditionally begin and end a few pages inside the book, where the knot won't show.

Formats always change the look of the book. Lin Westra uses the same stitch in two different formats to create two very different books: *Spirit Pouch* and *Metallic Whirl*. Alisa Golden's *Four in Transport* places four stab-bound books in a box with "wheels."

PHOTO: JIM HAIR

***Four in Transport*, Alisa Golden, Never Mind the Press.**

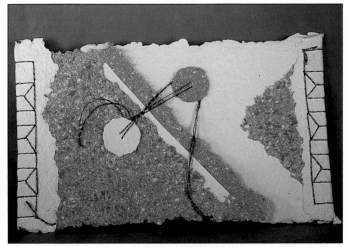

Examiner's Ledger, Lin Westra.

Spirit Pouch, Lin Westra.

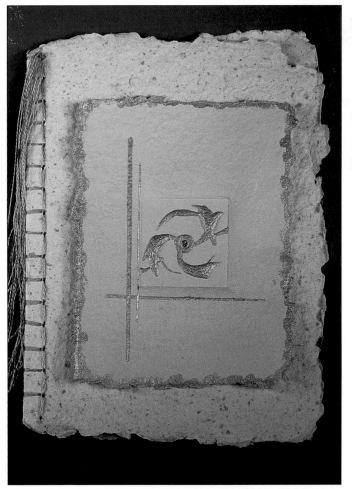

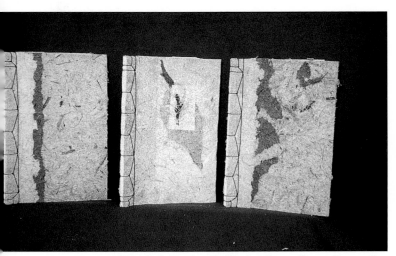

Untitled, Denise DeMarie, Grass Roots Paper Co.

Metallic Whirl, Lin Westra.

HEMP-LEAF BINDING

This is a slightly more complex pattern. Create the text and covers as you did for the project. Then mark and drill the holes in the pattern shown in figure 26.

Start by sewing from the back to the front through the fourth hole; then wrap completely around the spine and back into the same hole (Fig. 27).

Moving down the spine, continue with the same basic pattern you followed in the project: Sew into the next hole, around the spine, and back into the same hole (Fig. 28). Repeat, sewing into the next hole and around the spine (Fig. 29).

Continue down the spine, and complete the corner by sewing over the tail from both the last and next to last holes. Then sew upward, sewing into each hole sequentially—even if there is a stitch around the spine already—to fill in all of the empty spaces on both front and back (Fig. 30).

Although a plain paper cover shows the stitches best, some decorative treatments allow the stitches to retain their purity. Denise DeMarie uses her handmade paper very effectively as a decorative element, and Lin Westra uses format to create an interesting set that consists of two books bound to a single back board with a front closure. (See page 73.)

TORTOISE-SHELL STITCH

Create the covers and text just as you did for the project. Then mark and drill the holes as shown in figure 31.

This stitch pattern is slightly different from the previous ones. Here the holes become groups of three. The hole at the center of each group, the one deepest into the cover, is the pivotal hole for each group. From each pivotal hole, you will sew into each of its neighbors, then move to the next group.

Start sewing from back to front through a pivotal hole. Sew completely around the spine and back into the hole (Fig. 32). After sewing into the adjacent hole, around the edge, and back into the same hole, sew back into the original hole (Fig. 33). Then sew into the other adjacent hole. Sew completely around the edge and back into the same hole (Fig. 34).

Move on to the next group. Sew into that pivotal hole and repeat this process until finished (Fig. 35).

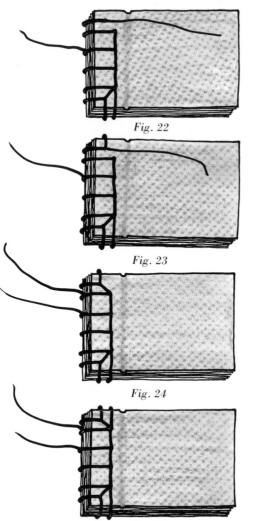

Fig. 22

Fig. 23

Fig. 24

Fig. 25

Models, Shereen LaPlantz.

Fig. 26

Fig. 27

Fig. 28

Fig. 29

Fig. 30

Fig. 31

Fig. 32

Fig. 33

Fig. 34

Fig. 35

Fig. 36

Fig. 37

TWO-HOLE PAMPHLETS AND NOTE BOOKS

Soft covers work well for these books. Select a water-color or other heavy paper for the cover, and cut two pieces the same size as the text. After placing the text between the covers, mark and drill holes as illustrated in figure 36. The holes should be placed symmetrically, but their distance from the edges isn't important.

The simplest two-hole binding is to sew through the holes and tie a knot in the center (Fig. 37). For a decorative touch, a different paper may be folded over the spine (Fig. 38). This also reinforces the edge.

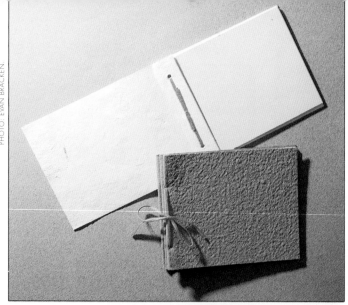

Models, Shereen LaPlantz.

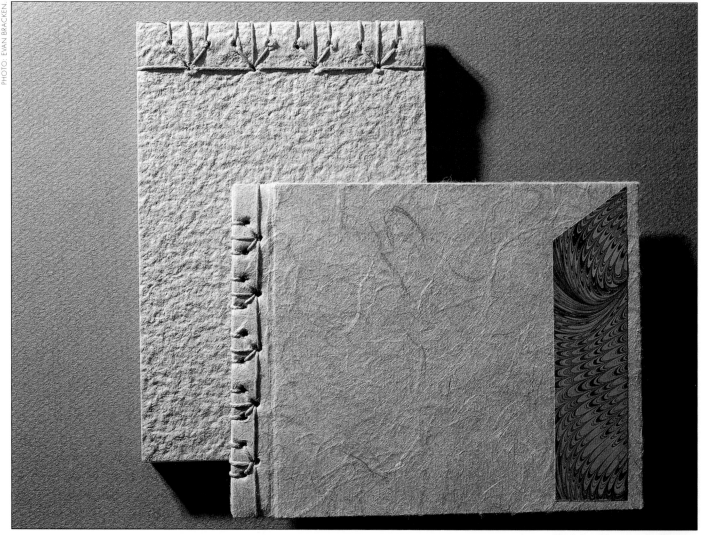

Models, Shereen LaPlantz.

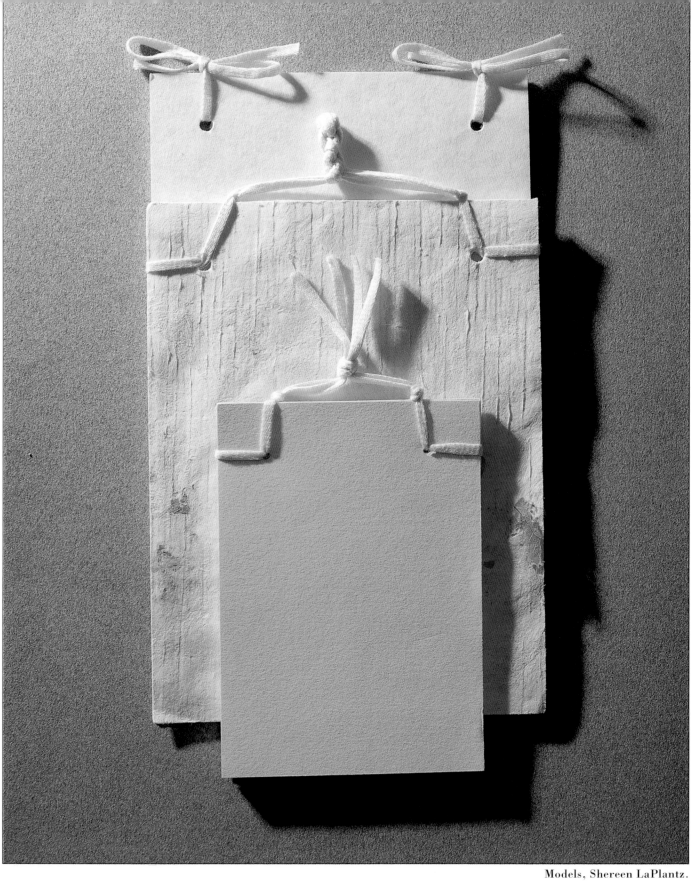

Models, Shereen LaPlantz.

Another option is to start sewing at the top and treat the holes as corners. The ends are tied right at the spine and again above the spine (Fig. 39).

Alternatively, the cover can hide the sewing. Cut one long piece of paper for the cover. It measures twice the length of the book, plus four times the length of the sewing area, plus the width of the spine. Fold and sew according to figure 40.

The cover can also hide a stitch pattern that looks more traditional. Cut two covers that are wide enough to include the sewing area. Position, mark, and drill holes according to figure 41. One set of holes is shown right next to the spine. When you make them, the holes should be just *over* the edge of the spine.

Start sewing as you would for any stab binding, going from back to front through the second hole from the top in the column closest to the fore edge (Fig. 42). Treating the holes next to the spine *as* the spine, sew through the adjacent spine hole and back into the original hole (Fig. 43). Sew into the next hole, and repeat until finished (Figs. 44 and 45).

NON-JAPANESE STAB BINDINGS

Stab bindings are a concept with many different applications. There are many stitches that you already know or will find in embroidery books that work for stab binding.

Quick cards and books can be created by using a running stitch or a double running stitch as a stab binding. Add traditional corners to the double running stitch, and the result feels even more like a Japanese stab-bound book.

Whip Stitch

The whip stitch works very well with stab bindings. Create a text block and covers. Then mark and drill a single column of evenly spaced holes (Fig. 46). Starting at the top hole, sew from back to front in a spiral down the spine (Figs. 47-49). Tie off the ends and trim the excess.

This whip stitch blurs the boundaries between stab binding and spiral binding. If the stitch is executed loosely and with a stiff sewing material, then it's more like a spiral binding.

Fig. 38

Fig. 39

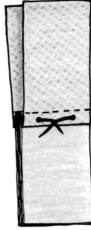

Fig. 40

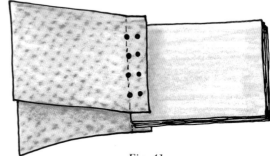

Fig. 41

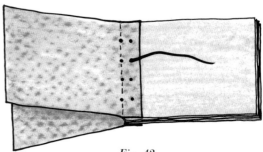

Fig. 42

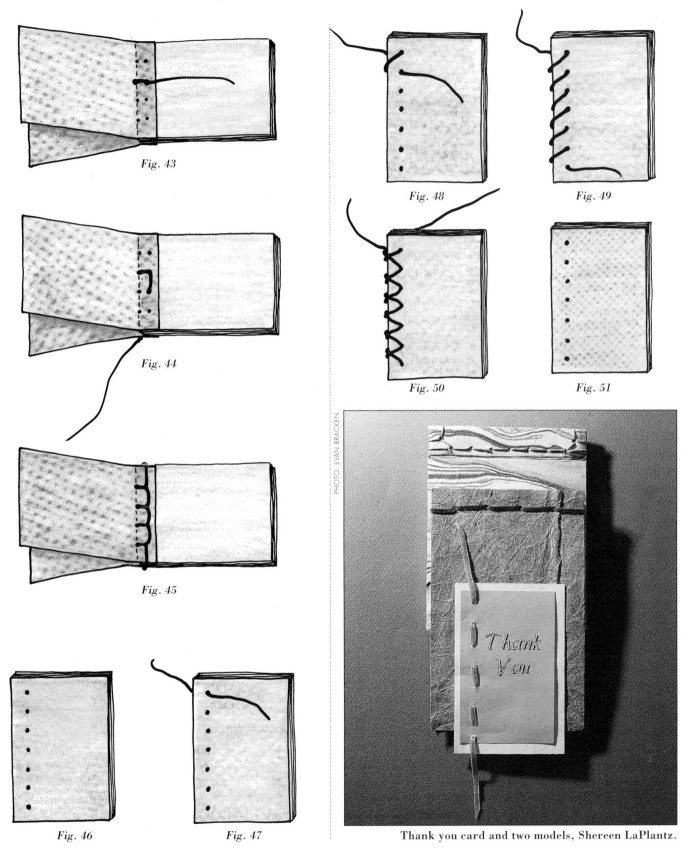

Fig. 43

Fig. 44

Fig. 45

Fig. 46

Fig. 47

Fig. 48

Fig. 49

Fig. 50

Fig. 51

Thank you card and two models, Shereen LaPlantz.

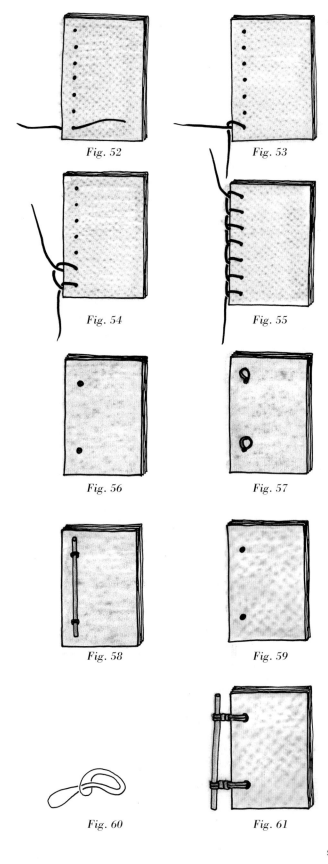

Fig. 52

Fig. 53

Fig. 54

Fig. 55

Fig. 56

Fig. 57

Fig. 58

Fig. 59

Fig. 60

Fig. 61

The whip stitch may be compounded too. Simply sew it twice, once down the spine and once up (Fig. 50). Tie off and trim the ends.

Lin Westra uses the double whip stitch in an unconventional format by binding two books onto a single back board. They're bound in the center and open in opposite directions.

Tip: Robin Renshaw, who teaches preschool, discovered that oversized pipe cleaners are very effective for this and other stab bindings. They're not only easy for kids to use, they're also great for adults.

Buttonhole Stitch

The buttonhole stitch is another familiar stitch that works for stab binding. After making a single column of holes through your text and covers (Fig. 51), start sewing at the tail (or the head; where you start is a personal preference). This stitch is different from the rest, and you must sew from front to back (Fig. 52).

Pull the beginning end around and loop it over the sewing end (Fig. 53). The beginning end is now hanging down. Sew into the next hole, front to back. While sewing out the back, stitch through the loop (Fig. 54). Adjust the tension. Repeat until finished (Fig. 55).

Tension makes this stitch lovely or ugly. Make the tension even for the best results.

Photo album and journal, Barbara Heisler.

Rubber Band Bindings

Another type of stab binding uses rubber bands threaded through the holes and held in place with a stick or similar object.

Create a text block and covers. The cover must be flexible or hinged; otherwise there will be too much strain on the rubber band when you open the book. Mark and drill two holes as shown in figure 56.

Using one long, sturdy rubber band, thread just the ends through the holes, leaving the long part of the rubber band on the back (Fig. 57). Hold the ends of the rubber band in place with a stick, bamboo skewer, knitting needle, or similar object (Fig. 58).

Another binding style has the stick at the spine. Start by making two holes through the covers and text block (Fig. 59). Using two rubber bands, thread each one through a hole. On each rubber band, slip one end through the other, creating a noose (Fig. 60). Thread a stick through the two nooses (Fig. 61).

Planetary Philanderings, Lin Westra.

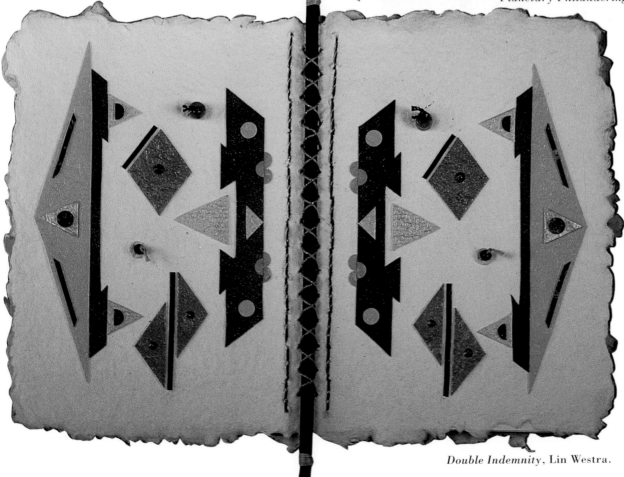

Double Indemnity, Lin Westra.

OTHER FORMATS

Remember that stab-bound pages may be folded into centerfolds, gatefolds, accordion folds, or whatever you wish. The books may be shaped, cut, or built one on top of another. The stitch patterns may vary, and it's possible to develop new stitch patterns or even to write words with the stitches.

Format models, Shereen LaPlantz.

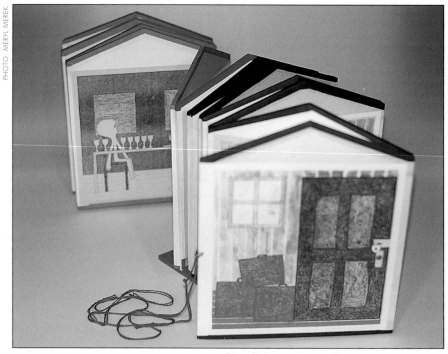

Two Sides to Every Story, Emily Martin.

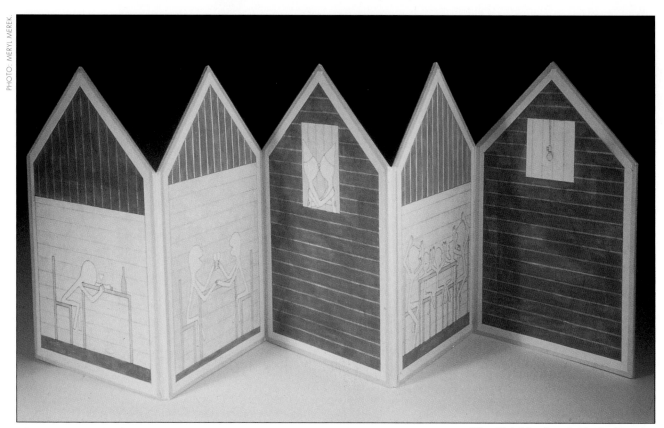

The Neighborhood, Emily Martin.

\mathbf{M}OST COMMON AMONG FOLD BOOKS are those with accordion folds. This zigzag-shaped fold is also called a concertina or leporello. In addition to these, there are many other types of fold books. This chapter includes concertina folds and several variations for folding single pages into simple or complex mazes.

Simple accordion folds, if made with a stiff material, don't require covers. *Two Sides to Every Story* and *The Neighborhood*, by Emily Martin, utilize this straightforward technique to make exciting, complex story books.

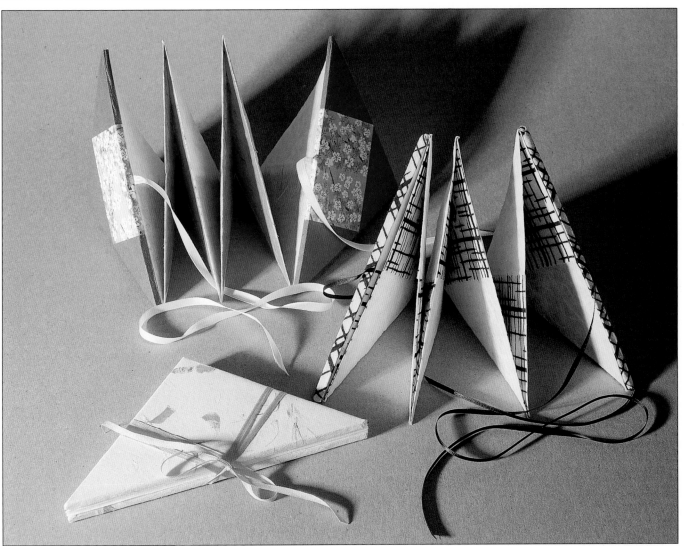

PHOTO: EVAN BRACKEN

Project models, Shereen LaPlantz.

PROJECT

Fold books may be rectangular or many other shapes. A triangular fold book looks interesting and special, and it makes an easy project. This book has accordion-folded pages with separate covers both front and back.

Because the text paper is quite soft, the covers must provide sufficient stability for the book to stand. That means the covers must be made of something exceptionally thick. Foam board is recommended for this purpose

Fig. 1

Figs. 2–6

Fig. 7

Fig. 8 *Fig. 9*

Fig. 10 *Fig. 11*

because it's thick but lightweight and because it's a totally different material than has already been used for covers. The drawback to this type of material is that it's soft, which means it can be dented or creased easily. Unless it is pampered, the cover will develop a battered appearance.

Materials

Text: Any calligraphic rice paper available in a roll, cut as described below

Endpapers: 1 piece of photocopier or other inexpensive paper, cut in a square whose dimensions are equal to the height of the text paper

Cover boards: 1 piece of foam board, cut the same size as the endpapers

Cover paper: 1 square piece of thin handmade paper, cut about 3" (about 75 mm) larger on each side than the cover board

Ribbon: Grosgrain or satin ribbon or cotton crochet tape

Scrap paper for pasting

Paste

Waxed paper

Tools

Mat knife or craft knife

Metal straightedge

Bone folder or similar tool

Book press or large, heavy weight

Process

1. Cut a piece of the calligraphy paper eight times as long as it is wide. To make a smaller book, the paper may be cut in half lengthwise.

If you decide to cut the calligraphy paper in half lengthwise to make a smaller book, you must do so carefully and accurately. Without straight edges and perfect measurements, fold books get sloppy fast.

2. Using your knife, cut the endpaper, foam board, and cover paper in half diagonally.

3. Cover the triangular-shaped boards with the pieces of cover paper (Fig. 1), following the instructions on page 43 for making non-90-degree corners. Paste two ribbons in place, one just long enough to tie and the other long enough to wrap twice around the cover

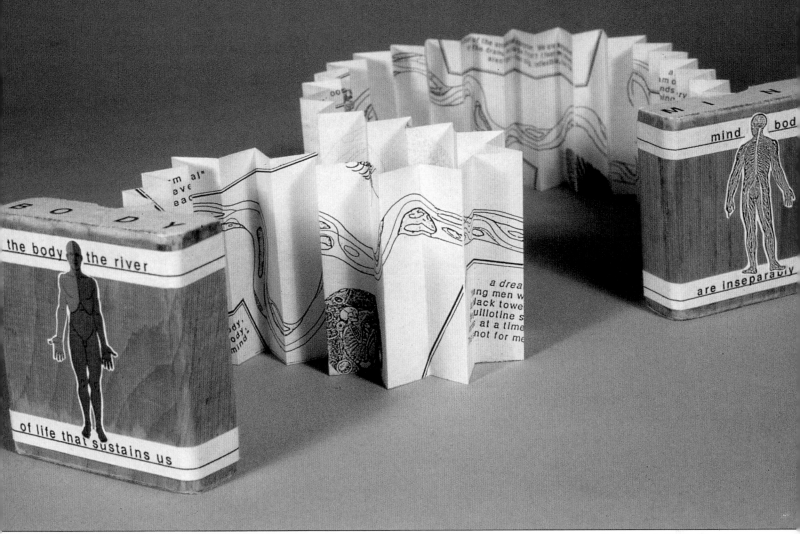

Bodymind, Genie Shenk.

before tying. (See page 42 for instructions on pasting ribbons.) Then paste the endpapers in place. After wrapping the two covers in waxed paper, place them under a heavy weight to dry.

4. Start with the text paper stretched in front of you horizontally (Fig. 2). Holding one end against the work surface, fold the paper down to make a diagonal fold (Fig. 3). Be especially careful that the corner is perfect and that the edges match perfectly at the left side.

Tip: Small errors multiply in fold books. It is especially important that perfection is achieved, or monstrous gaps will appear by the end.

5. Now fold the long end of the paper up (Fig. 4). Again, the corner must be perfect and the left side must match.

6. Fold across to the left (Fig. 5). Make a perfect corner again, but this time match the bottom edges.

7. Fold across to the right (Fig. 6), again making a perfect corner and matching the bottom edges.

8. Repeat the folding sequence—down, up, left, right—until you're finished (Fig. 7). Be careful at each step to have the edges match and the corners perfect. If you have any excess paper at the end, trim it to make the last triangle perfect.

9. Paste the first page inside the front cover and the last page inside the back cover (Fig. 8). Then wrap the book in waxed paper and dry it under weight.

10. The longer ribbon tie is tied in a figure-8 pattern, wrapping first around one side (Fig. 9), then the other (Fig. 10) before tying with the shorter ribbon (Fig. 11).

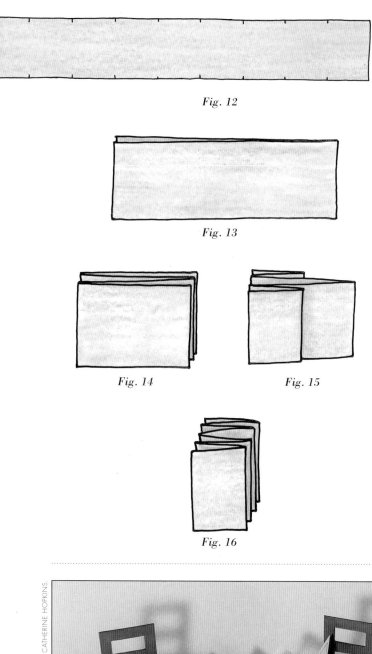

Fig. 12

Fig. 13

Fig. 14 Fig. 15

Fig. 16

SHAPE VARIATION

The 60-Degree Triangle

In addition to right-angle triangles, other triangular shapes may be folded. The 60-degree triangle as a fold book has a few surprises. The pages don't all fold to the same length, and a pattern of long, short, short, long develops. When the pages are bound in the style of a codex, the book has pockets, some right side up and others upside down.

Rectangular Fold Book

The concertina fold also works well as a rectangular book. Folding is best accomplished by either of two methods. In the first one, carefully measure and mark each page (Fig. 12). Then fold according to the marks. Be very careful to make the edges match perfectly, even if the marks must be adjusted.

The other method is to fold in half repeatedly. Start with the full length of paper, and fold it in half perfectly (Fig. 13). Now fold each half in half, folding the edges back toward the center (Fig. 14). Then fold each section in half again (Fig. 15). The original fold (at the center) is folded in the wrong direction for a concertina; it must be refolded inward (Fig. 16). As you fold, always watch that the edges match. Continue folding in half, then quarters, eighths, and sixteenths until the pages are the desired width.

There are many options with something this simple. Lois James and Mary Ellen Long link separate pages as if they were folded. Edward H. Hutchins' work incorporates die-cut pages and unusual covers.

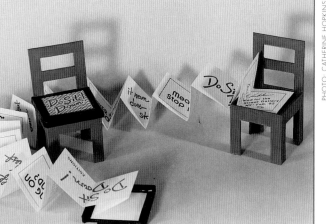

Do Sit Down, Edward H. Hutchins.

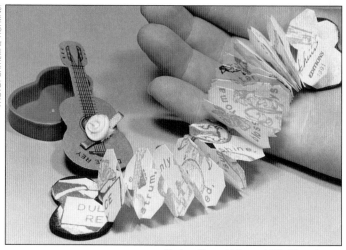

Dulce Rey, Edward H. Hutchins.

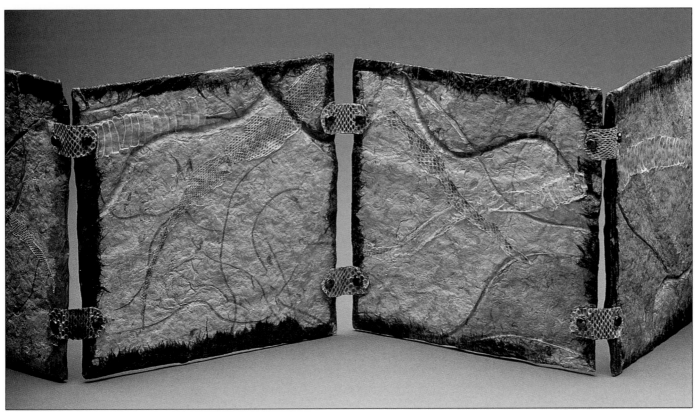

Snake Space, Lois James.

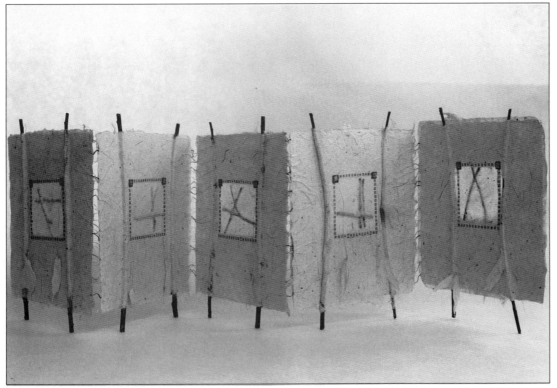

Crossing of the Aspen, Mary Ellen Long.

FLUTTER BOOKS

The same rectangular text block created above may be used for a flutter book. Make a regular cover, complete with a spine, and paste a single endpaper sheet over the entire inside surface of the cover (Fig. 17).

Paste the first page of the folded text paper to the inside front cover and the last page to the inside back cover. Wrap the book in waxed paper and place it under a weight to dry.

When finished this book looks quite like the basic codex except that the pages are folded at the fore edge. The difference becomes obvious when the book is tipped forward: The text block flutters out (Fig. 18), hence the name.

THREE-IN-ONE FOLD BOOKS

This book has three (or more) narrow folded text blocks. Two of these text blocks are attached with the first and last folds facing forward, and the middle one is attached with the first and last folds facing back, giving quite a bit of dimensionality and improving stability.

SINGLE SHEET FOLD BOOKS (MAZES)

These books all work from the concept of folding, then cutting part of the folds to open a single sheet of paper into a book. The cuts cause the pages to develop unusual formations that are sometimes complex, similar to mazes. There are spaces for stories within stories, digressions and asides.

As you develop your own book mazes, the final folding pattern may elude you. Just be patient. Learn the rhythm of these folds by starting with the simple books and following the illustrations through to the more complex ones. When creating your own designs, start in the center and work your way out. There may be several different possibilities for the final outcome. Whichever you choose is correct; you are the designer.

A standard-sized sheet of paper works wonderfully for your first efforts. By the way, these simple books are often called *origami* books.

Single-Cut Maze

Fold a sheet of paper in half lengthwise and in quarters crosswise; then open it again. Cut down the center with a craft knife, cutting across the center two quarters (along the solid line in figure 19).

To form the book, pinch the two centers on either side of the cut. Gently pull them apart and down (Fig. 20). Then shape the paper into accordion-style folds to make a book (Fig. 21). A cover can be added if desired.

Variation on a Single Cut

This book maze uses the same folds as the first one: in half lengthwise and in quarters crosswise. Make a straight cut coming in from one end (Fig. 22).

Pinch the solid end together and make the accordion folds to create the book (Fig. 23).

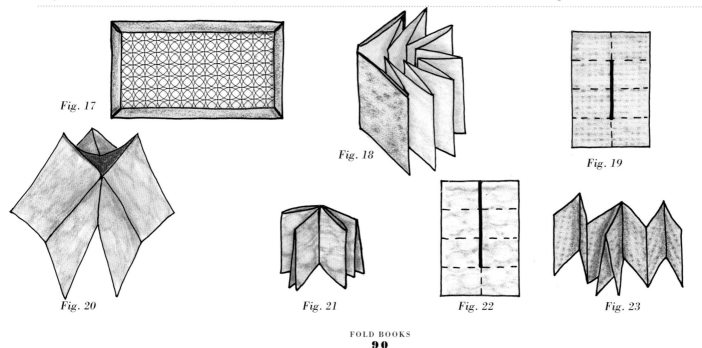

Fig. 17

Fig. 18

Fig. 19

Fig. 20

Fig. 21

Fig. 22

Fig. 23

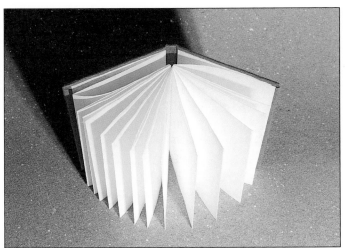

Model, Shereen LaPlantz.

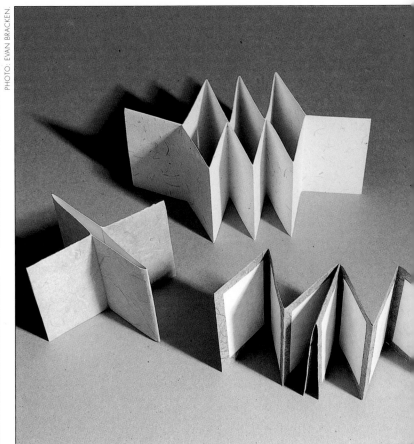

Models, Shereen LaPlantz.

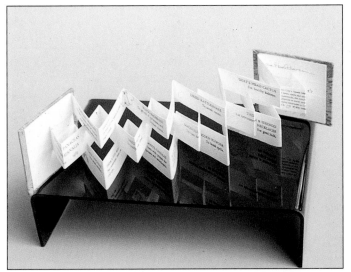

Potions, Panaceas & Paraphernalia,
Pat Baldwin, Pequeño Press.

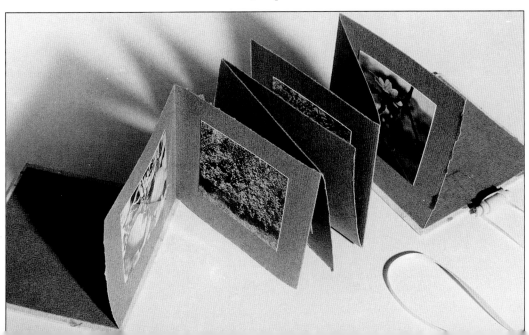

Untitled, Nancy McIntosh.

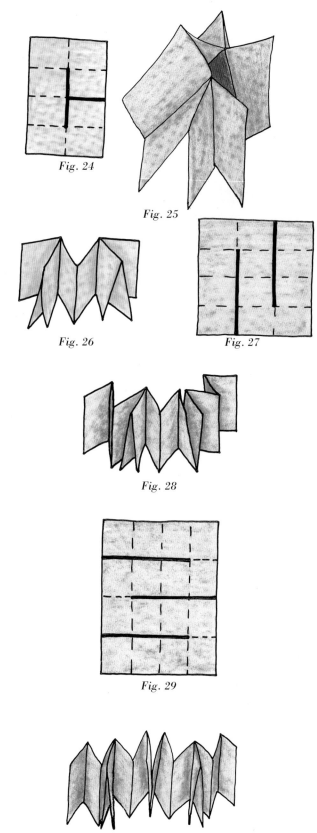

Fig. 24

Fig. 25

Fig. 26

Fig. 27

Fig. 28

Fig. 29

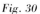

Fig. 30

T-Shaped Cut

Again use the same folding pattern, but this time cut a T, starting at the center of one side (Fig. 24).

Pinch the two ends together and pull down, shaping the paper into accordion folds to make a book (Fig. 25). Notice the two tent-shaped folds (Fig. 26). This type of fold will occur whenever you fold across the sheet rather than lengthwise along it.

Tip: The paper must be cut so that every section connects to two, and only two, other sections. Pinch the paper together at the end of any cut and start making accordion folds.

Multiple Cuts

For this pattern, fold the paper in thirds lengthwise and quarters crosswise. Cut two straight lines from opposite ends (Fig. 27).

Pinch the paper at the ends of both cuts and start making accordion folds (Fig. 28). Notice that one of the tent-style folds is upside down; that's correct.

For another variation, fold the paper in quarters both lengthwise and crosswise. Then make three cuts (Fig. 29).

Pinch the end of each cut, and start making accordion folds in between the pinches (Fig. 30).

Variations on a T-Cut

Fold the paper in thirds lengthwise and sixths crosswise. Taking the concept of the T-cut from above, continue it into cuts shaped like ram's horns (Fig. 31).

Pinch the two sections at the end of each ram's horn and start accordion folding (Fig. 32). Notice that when three sections are together across the width they form an N and a backwards N.

For a second variation, fold the paper in quarters, both lengthwise and crosswise. Cut a simpler ram's horn or a T with serifs (Fig. 33).

Pinch the two sections at the end of each ram's horn. Working both backwards and forwards, make the accordion folds (Fig. 34). Notice that the center section forms an M.

Complex Cutting Patterns

To make a more complex variation, fold the paper into quarters lengthwise and eighths crosswise. Make cuts similar to ram's horns (Fig. 35).

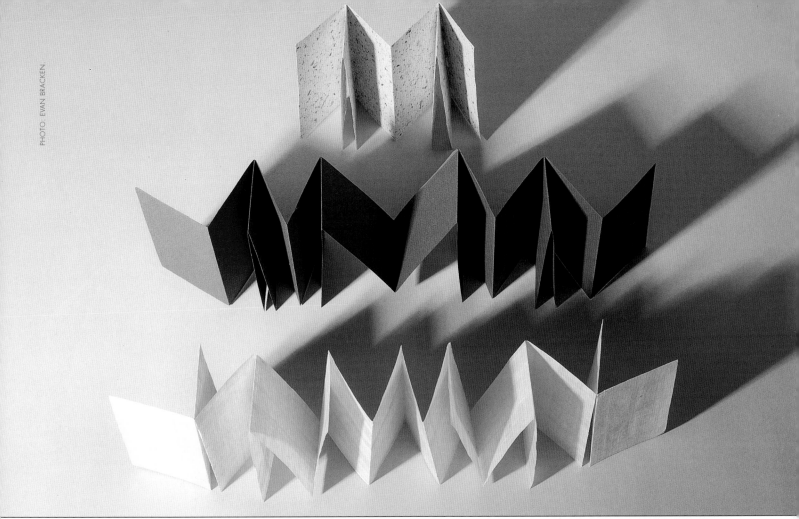

Models, Shereen LaPlantz.

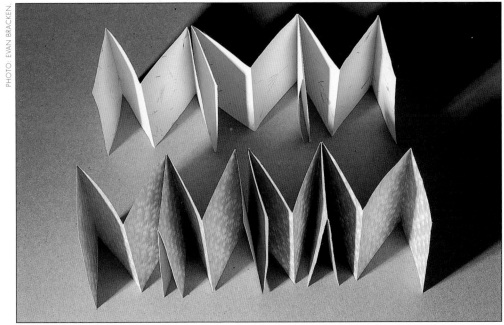

Models, Shereen LaPlantz.

FOLD BOOKS

Pinch the two sections at the end of each ram's horn and start making accordion folds. No matter how large and complex, the concept is the same: pinch and start folding. Just work methodically around the book.

There can be many cuts. One pattern creates a book with asides and hidden sections. Fold the parent sheet into quarters lengthwise and eighths crosswise. Then make the cuts as shown in figure 36.

Start pinching at the ends of any serifed T. It might help to pinch the ends of all three serifed T's. Then work your way out by making the accordion folds. Note that occasionally the pattern will develop a small section that wants to fold inside the pages of another section. These areas can become digressions in your text; they're almost like secret gardens.

One final maze book uses the same original fold—in quarters lengthwise and eighths crosswise. Make the cuts shown in figure 37.

Make the first pair of pinches outside the two short side cuts. Then see if it's possible to work the accordion folds. Alternatively, make pinches at each interior end of the cuts. Then make the accordion folds. This one has *lots* of nooks and crannies.

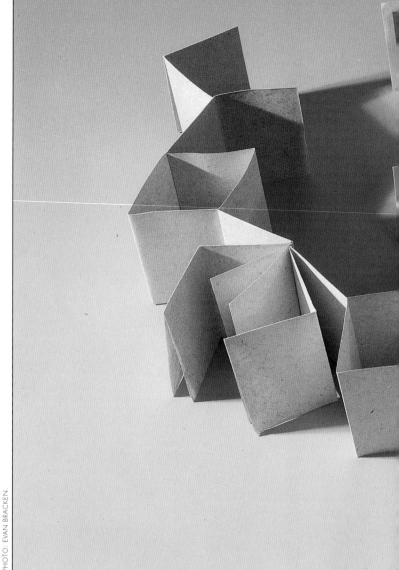

PHOTO: EVAN BRACKEN

Fig. 31

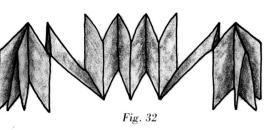

Fig. 32

Fig. 33

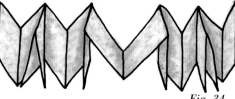

Fig. 34

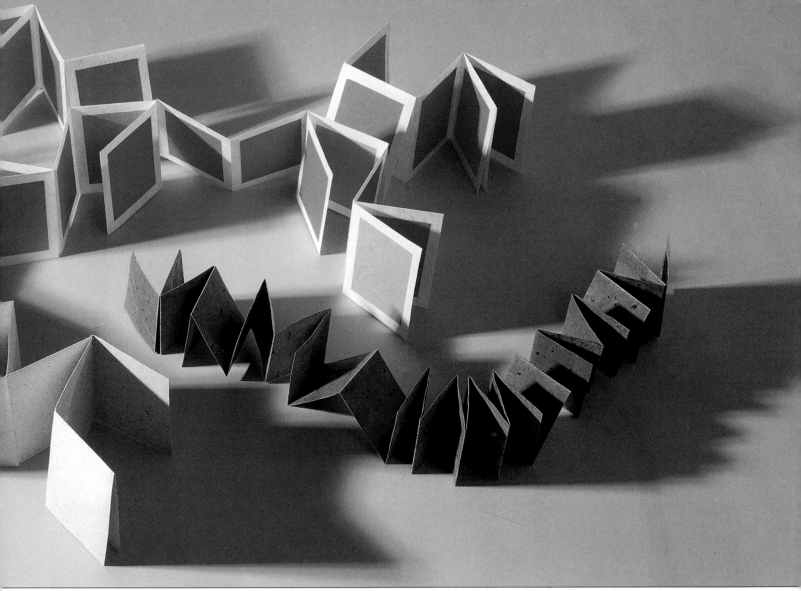

Models, Shereen LaPlantz.

Fig. 35

Fig. 36

Fig. 37

FORMAT ALTERNATIVES

There are countless format possibilities for fold books. The folds can be uneven, or they can be cut and folded inside themselves. Folds can be pasted onto folds, folded up into boxes, or formed into gum wrapper chains. They can also rotate or corkscrew. Cuts don't have to be perpendicular to the edges of the page; they can also be made diagonally. The binding can be a curled fold, or the covers can hinge. And, of course, folds are the beginning step for pop-ups.

Them Poems, Pat Baldwin, Pequeño Press.

PHOTO: CATHERINE HOPKINS.

Twisted, Edward H. Hutchins.

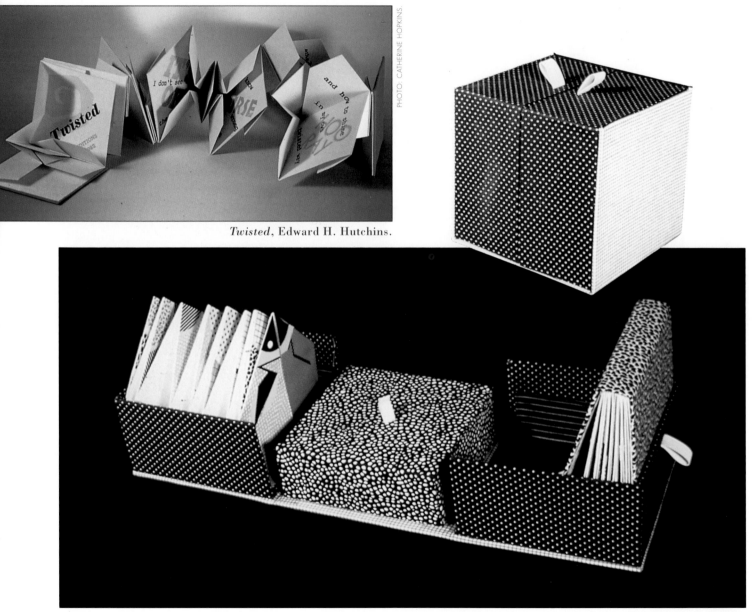

Above and opposite: *Book-in-a-Box*, Nancy Callahan.

Rhythmic Notes on 7 Folds, Carol Barton.

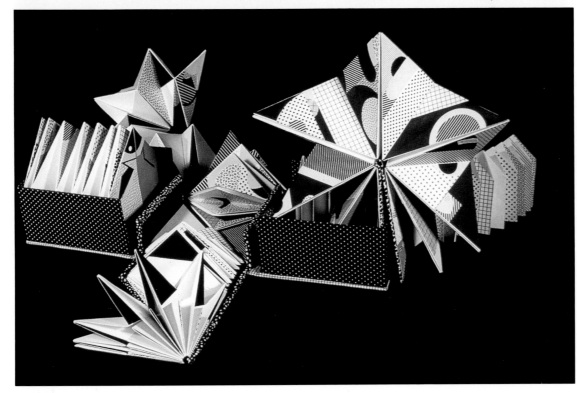

Another Variation

The six photographs on these two pages illustrate yet another alternative—the puzzle book. A puzzle book starts with a flat piece of paper that is cut and folded in toward the center, making a single square. As the square is unfolded, new and larger images emerge.

All photos this and opposite page: *Life Is a Kaleidoscope,* Dorothy Swendeman, A Weaver's Press.

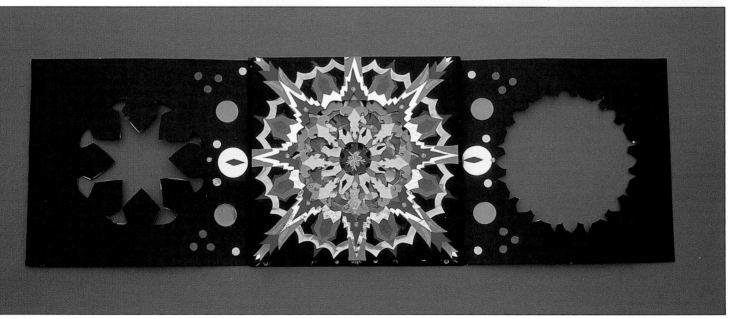

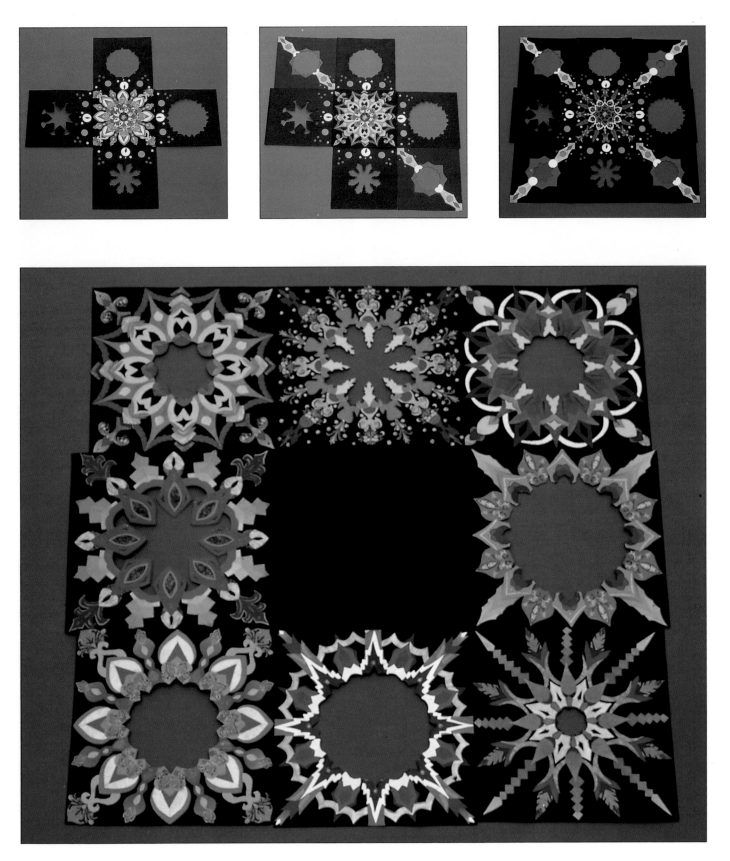

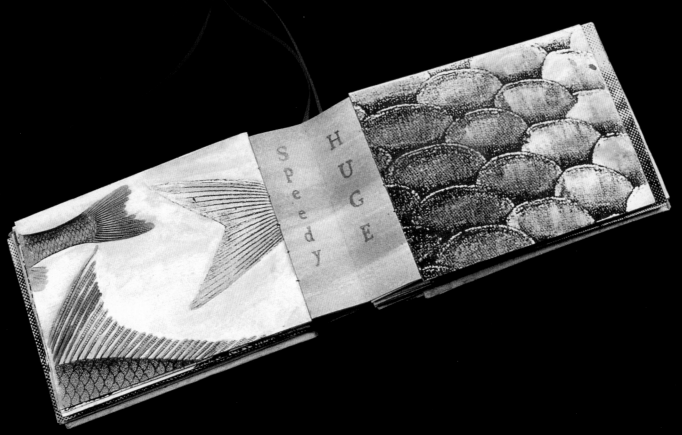

Photos this page: *Fish Diary*, Lois James.

BOOKS THAT INCLUDE a combination of folding, sewing, and pasting techniques offer the largest range of structural possibilities. This type of book can be simple, almost a basic codex, or it can have hidden panels, tunnels, or flags that snap into position when the book is opened.

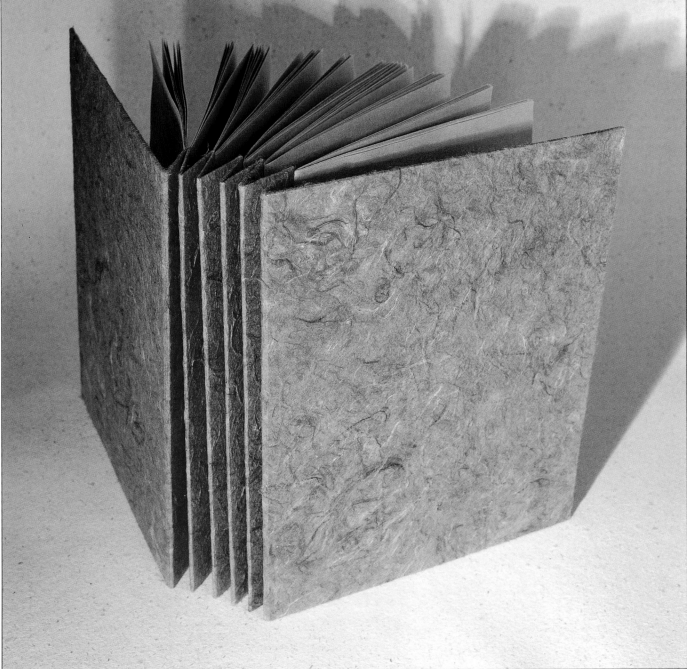

Project model, Shereen LaPlantz.

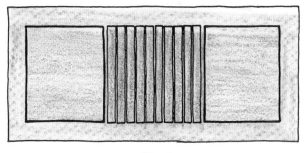

Fig. 1

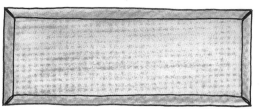

Fig. 3

Fig. 4

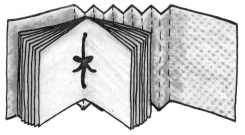

Fig. 2

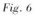

Fig. 5

Fig. 6

PROJECT

This book is a simple combination. The spine is folded with a concertina spine, and the signatures are sewn to the spine. There is just one potential dilemma with this design: If a concertina spine is made using stiff paper, it may work or it may slump. Unfortunately, the tendency is to slump because the paper isn't strong enough to support the signatures. If a really stiff paper similar to a lightweight board is used, it may crack after repeated folding.

The answer to this materials problem is to make lightweight board slats and cover them with a soft, durable decorative paper. The slats provide the support, and the decorative paper makes the hinges, allowing the concertina spine to fold easily. If the book will be used extensively, reinforce the folds with tape. Paper or linen tape used for mounting prints is good for this. It's sold in most art supply and framing stores.

Materials

Text: 40 sheets of standard-sized paper, each folded in half
Endpaper: 1 piece of strong rice paper or other handmade paper, cut as described below
Cover boards: 12 pieces of any appropriate board (see page 12), cut as described below
Cover paper: 1 piece of unryu or other strong rice paper, cut as described below
Scrap paper for pasting
Waxed paper
Paste

Tools

Mat or craft knife
Metal ruler or straightedge
#22 or #24 tapestry needle
Tea towel or paper towel folded into quarters lengthwise
Pencil
Push pin, awl, or equivalent
Beeswax
Book press or large, heavy weight

Process

1. Measure and cut two pieces of board 1/4" (6 mm) longer and 1-1/4" (32 mm) wider than the folded text. Cut ten narrow slats, each about 1" (25 mm) wide and as long as the other cover pieces. Lay them next to one another, carefully measuring a 1/8" (3 mm) gap between

each piece (including the slats). If you plan to use tape, apply it now. Each piece of tape should be as long as the board or slat and should cover the entire open gap between two boards. Remember to place the tape on the outside of the cover boards.

2. Measure and cut the cover paper, making it 2" (50 mm) longer and wider than the assembled cover. Then paste the boards onto the cover paper (Fig. 1). Form the corners, just as you would for any other cover.

3. Measure and cut the endpaper 1/2" (13 mm) shorter and narrower than the assembled cover. Then paste the endpaper onto the inside of the cover (Fig. 2).

4. Fold the spine into a concertina *before* wrapping it in waxed paper and drying it under weight (Fig. 3). To work properly, the folds require a bit of give. Once everything is dry, there's no chance that the papers could be eased to allow the folds; instead, they would crack along the fold lines.

5. Now make the signatures. With eight sheets of folded paper (i.e., 32 pages) per signature, these are fuller than normal (Fig. 4). The larger signatures are necessary to fill the space created by the folded spine. If the extra pages weren't used, then the book would form a wedge with the spine wider than the fore edge.

6. Sew the signatures onto the spine, on the *mountain* folds (those facing the fore edge). A pamphlet stitch is used in the illustration (Fig. 5), but a running stitch would also work.

7. Continue sewing signatures onto the spine until the book is complete.

Lessons From Green Gulch, Susan Kapuscinski Gaylord.

SIGNATURE VARIATIONS

Double Signatures

If you don't wish to have the fuller signatures needed to avoid a wedge-shaped book, then you can attach two regular signatures to each fold.

From paper that is heavy enough to support two signatures, cut a small piece for each fold in the spine. Similar to spacers, these pieces should be equal in length to the spine and twice the width of one slat plus about 1" (25 mm). Fold each piece in half lengthwise.

Sew two regular signatures to each piece of paper, placing each signature about 1/2" (13 mm) from the fold (Fig. 6). Then paste the papers onto the folds of the spine (Fig. 7). Separate each signature with waxed paper and dry them all under a heavy weight.

Folded Pages

Pages within a signature aren't always simple, flat pieces of text paper. They can also have folds. Select whatever style of fold you like best; a gatefold is shown in figure 8. In *Lessons from Green Gulch* Susan

Fig. 7

Fig. 8

Fig. 9

Fig. 10

Fig. 11

Fig. 12 *Fig. 13*

Kapuscinski Gaylord uses centerfold pages.

Fold the desired number of text pages and form a signature by nesting them together (Fig. 9). Then sew the signature onto the spine.

A Secret Hiding Place

The Separate Piano Hinge

Another method for reinforcing the concertina spine is to use a hinge. The hinge is made of lightweight board and extends across the entire spine. When the hinge pin is removed and the hinge opened, an unexpected hidden compartment is revealed. This compartment could hold the answer to the story's puzzle, a different slant on the story, or a final, special illustration.

Although the hinge reinforces the concertina spine, my preference is to use slats also. That way, the finished book feels a bit more durable.

When making a hinge, the first step is to choose the hinge pin. What will it be? A pencil, bamboo skewer, metal rod, or anything similar will work. The hinge pin dictates what size the hinge must be.

The hinge consists of two components (Fig. 10). One, which looks like a ladder, makes the barrels that hold the hinge pin. The other, resembling a square-edged number 8, contains the holes. After forming, the barrels fit neatly into the holes.

Measure the circumference of the hinge pin with a piece of scrap paper. That measurement, plus 1/4" to 5/16" (6 to 8 mm) for ease, is the width of both the holes and barrels. Here is an example: My hinge pin was a bamboo skewer with a 3/4" (19 mm) circumference. Therefore, my hinge holes and barrels were 1" (25 mm) wide *before* forming.

Now cut two pieces of lightweight board. They should be the full length of the spine, and their width should measure 2" (50 mm) plus the hole/barrel width.

Decide how many holes and barrels are desired; then carefully mark and cut the openings. Remember, the two components must fit snugly with each other to act as a hinge. Also remember that they will be covered with decorative paper, which will take up a tiny bit of space. Allow for that little bit extra.

Cover the hinges with either the same paper used on the covers or with a complementary paper. To cover the rectangular holes, cut an X in the paper at the opening. For the gaps at the end of the barrel, make a Y-shaped cut (Fig. 11).

Fig. 14

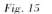

Fig. 15

Fold and paste back the flaps from the X's and Y's (Fig. 12). Then finish making the corners and covering the hinges.

Fold and form the hinges around the hinge pin. Then fit the two parts together, and test the assembly to make sure the pin fits snugly but easily into the hinge (Fig. 13). If it doesn't, start over.

Finish the book by pasting the hinges onto previously finished front and back covers (Fig. 14). Then paste the concertina spine to the inside of the hinged cover. When the signatures have been sewn onto the spine, the book is finished (Fig. 15).

If someone goes to the trouble of removing the hinge pin, they're going to expect a payoff. Is there something wonderful on the back of the spine? Plan a colorful surprise for your hinged books.

Fig. 16

Fig. 17

Fig. 18

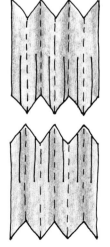

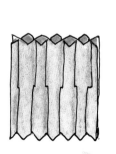

Fig. 19 *Fig. 20*

Piano Hinge as Part of the Cover

It's possible to make the piano hinge together with the cover. This approach requires cover board that is flexible enough to bend and form the hinge; a single-ply museum board or a plate Bristol would work. When the board is this flexible, however, the cover feels soft and unsubstantial.

Measure for the hinge and covers just as before. Mark both on the board. Carefully position the hinge holes next to the cover's edge (edge to edge). Cut the board according to the marks (Fig. 16).

After folding and forming the hinge, paste the unattached edge of each hinge to the cover (Fig. 17). Finish the book as described above.

HONEYCOMB CONCERTINA

Another method of reinforcing the concertina spine is to make it a double. By slitting halfway up and halfway down on two concertina-folded spines, you can slip one into the other to form a honeycomb. Afterward, signatures can be sewn onto the spine and covers pasted in place. This style is most effective on short books (quarto height is good). When the book is taller, the slits cause flimsiness.

Select a sturdy or heavy paper, such as a charcoal or watercolor paper. Vellum finishes are probably too soft. Then measure and cut two pieces the desired size. Measure and pressure score the concertina folds in both pieces. Halfway in between each fold, measure and cut a slit half the height of the paper (Fig. 18).

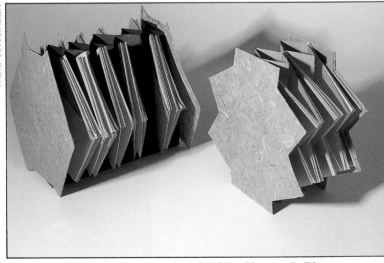

Models, Shereen LaPlantz.

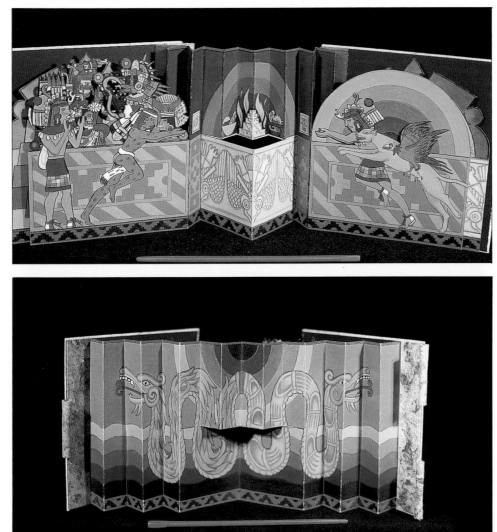

Top and left: *The Sun of the Four Movements*, from *Yancuic Tonatium Valmomana*, book 6 of 9, Elsi Vassdal Ellis, EVE Press.

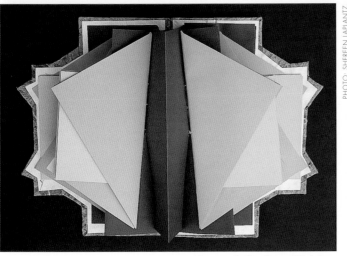

Journal, Barbara Heisler.

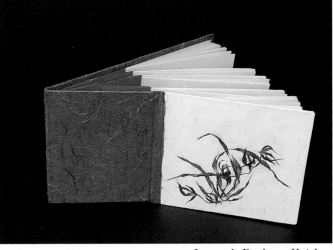

Journal, Barbara Heisler.

Fig. 21

Fig. 22

Fig. 23

Fig. 24

Fig. 25

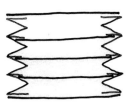

Fig. 26

Fold the papers and slip them together (Fig. 19), interlocking the slits (Fig. 20). Then sew on the signatures and attach the covers.

Tip: It's easier to sew signatures onto the mountain folds before the two concertinas are interlocked. On the other hand, it's easier to sew onto the valley folds after they're interlocked.

FLAGS

The concept behind this book is that a fold has two sides, each going in a different direction. If a flag is pasted to one side of the fold, it will lie down heading in one direction; if pasted to the other side, the flag will lie pointing in the other direction. A third possibility is not to let the flags lie down. Then the folds with flags could turn, like pages.

This provides several design possibilities. The flags could have images on one side and words on the other, or they could have both on both sides to tell two sides of a story.

First create a concertina spine. Then paste rows of flags on both sides of the folds, some on the left and others on the right (Fig. 21).

TUNNEL BOOK

A tunnel book has concertina sides and no spine. Pages are attached to both sides of the concertina, leaving them firmly in place. The pages have cutouts, allowing the reader to view through the holes, with an almost telescopic effect. Because you must view through one page to see the next, you shouldn't plan on having many pages. Otherwise, the cutouts become too small to view through them adequately.

Start by making two concertina spines, one for each side. Notice that the folds are actually angles. That causes a problem for the pages, which must be perpendicular to the tunnel. To solve it, cut tabs to hold the pages (Fig. 22). In figure 23, an overhead view shows how the tabs are held in position.

Design, illustrate, and cut the pages for the interior of the tunnel (Fig. 24). To hold them together, a frame is placed on the front, and the back is usually a solid piece of heavy paper or board. Paste the pages onto the tabs. Then paste the front and back in place (Figs. 25 and 26).

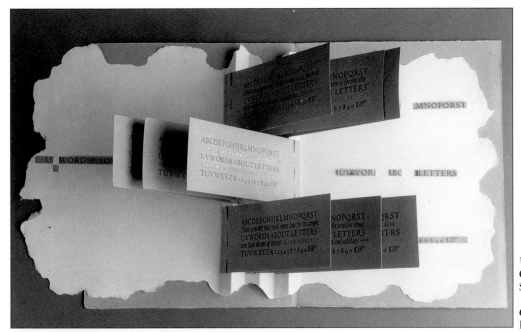

Words About Letters,
Carol Pallesen Hicks,
Silent Hand Scriptorium.

Cincinnati 3 Way,
Paddy Thornbury.

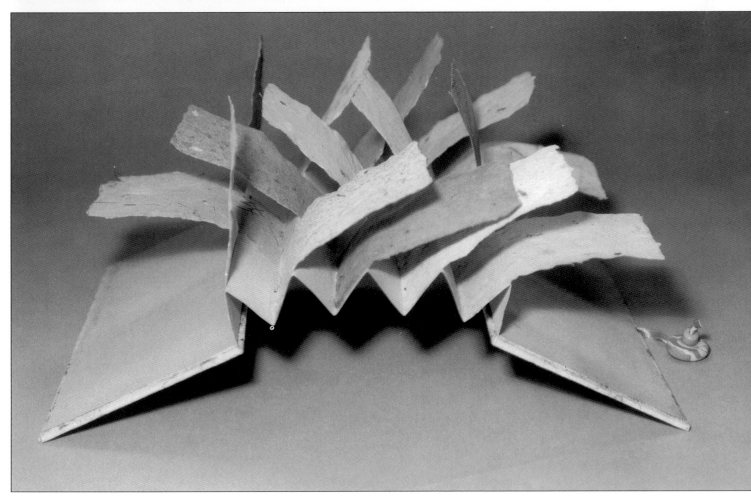

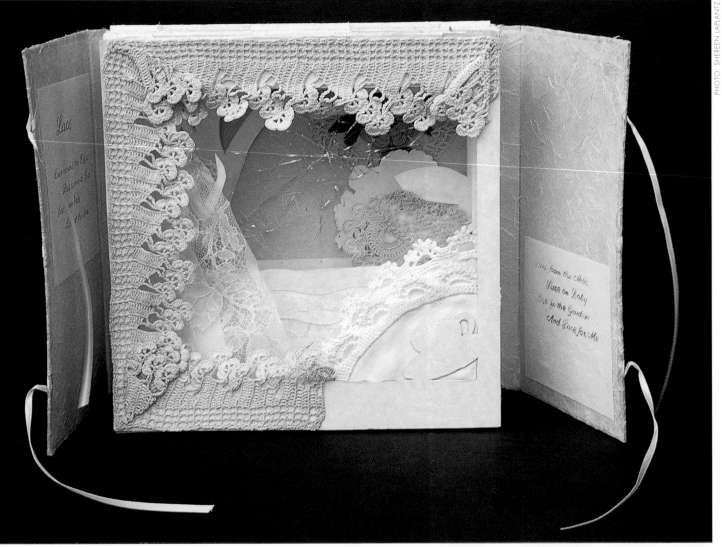

Lace, Dorothy Swendeman, A Weaver's Inn Press.

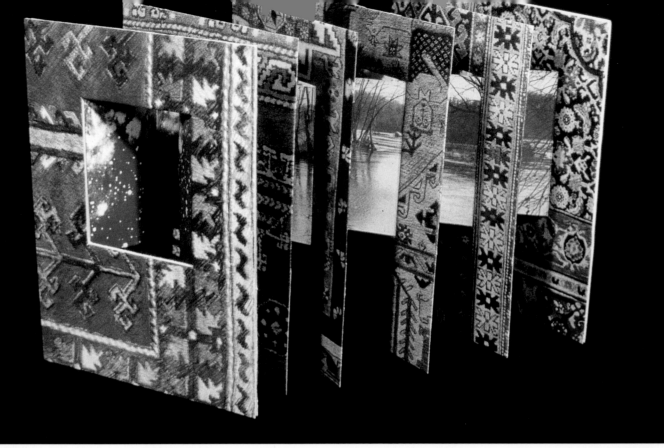

Loom, Carol Barton.

Tunnel Map, Carol Barton, produced at Women's Studio Workshop.

Grandma's Closet, Edward H. Hutchins.

Miniver Cheevy, Pat Baldwin, Pequeño Press.

STAR BOOK

There are two types of star books—the one discussed on page 47 and this one. This star is a variation of the tunnel book. It consists of three layers of concertina folds, with cutouts, sewn together on the fore edge.

The size of the folds is important for a star book to work. The back layer has a large, deep fold and the front layer has a shallow fold. Unfortunately the decrease/increase in size isn't equal; it's graduated. The difference in width between the deep fold and the middle one is twice that between the middle fold and the shallow one. For example, if the back layer has a 3" (76 mm) fold and the middle layer has a 2" (51 mm) fold, then the front layer should have a 1-1/2" (38 mm) fold.

Design and create three layers of concertina (Fig. 27). Then nest the three layers together in order, placing the shallowest fold in the front (Fig. 28). Sew them together on the fore edge (at each mountain fold). Either a pamphlet stitch or running stitch will work.

Attach the cover to the end pages so that the shallow folds face outward, displaying the cutouts (Fig. 29). Remember, if the star opens into a complete circle, the cover must have a soft spine (without a board).

Fig. 27

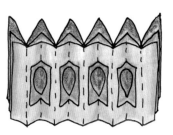

Fig. 28 *Fig. 29*

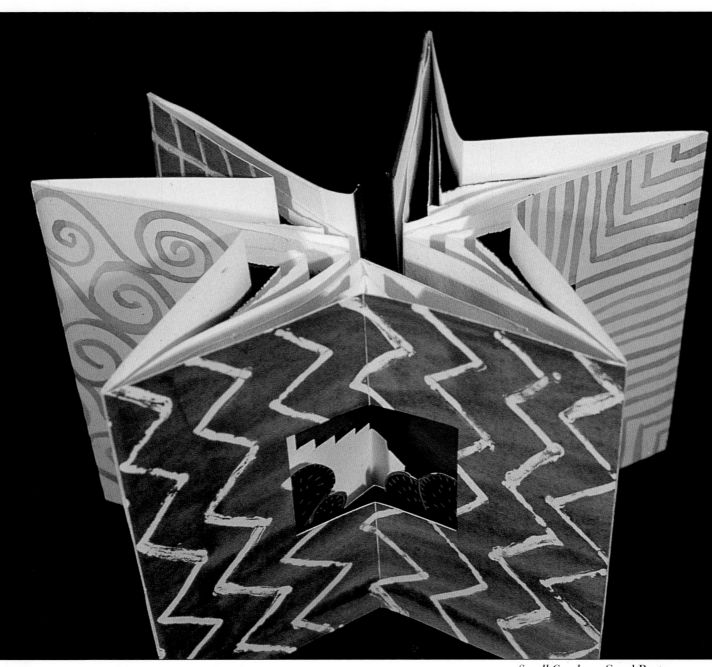

Small Gardens, Carol Barton.

FORMAT VARIATIONS

For combination books, format is as primary as technique. In fact, the books themselves are formats, since each variation is not just a stitch or a fold. Although we've looked at several possibilities, these books can be taken still further. Could the tunnel book have another tunnel within it? Could the star have an arm folding out? Be careful not to get too gimmicky or contrived. Each structure must grow out of the book's content. If the star book allows peeks at old family photos then perhaps it should be shaped like the family tree. Think about the subject; then design the book.

Format models, Shereen LaPlantz.

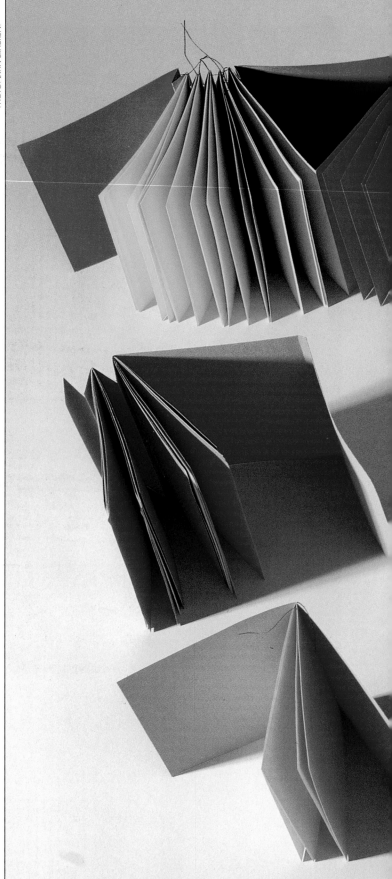

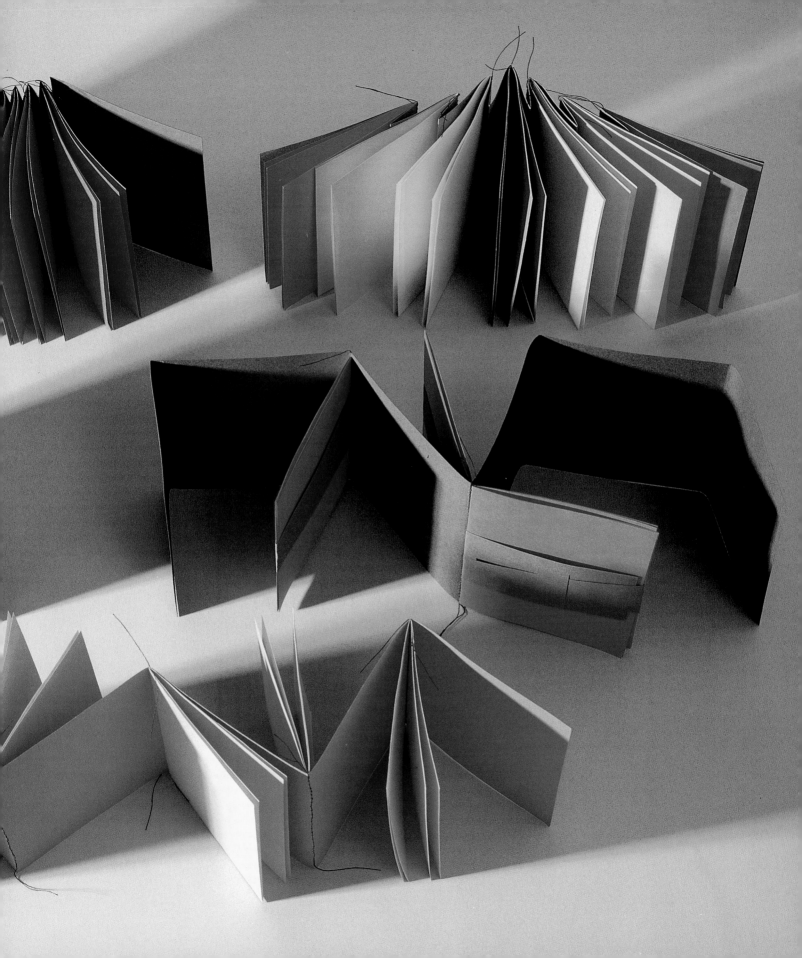

THESE ARE THE BINDINGS that don't fit elsewhere, so that means this chapter is a bit of a pot-pourri. Previously, a stick was used as part of a hinge; in this chapter, sticks will become entire bindings. They will make piano hinge bindings and a variation on library newspaper bindings. In addition to the stick bindings, this chapter includes some laced, ring, and spiral bindings.

One of the simplest bindings is one done by Mary Street in *Dreamwave*. It's created while drying hand-made paper. Insert a number of the still-damp sheets part of the way into a book press and apply pressure. The pages will be welded together wherever they have been pressed.

Dreamwave, Mary Street.

PROJECT

This book incorporates a piano hinge, which is a simple and effective means of connecting two signatures. The text paper shows in this book—in fact it's highlighted—so it should be lovely. The cover must be heavy yet flexible enough that it will fold to form its portion of the hinge. The sticks become the focal point on the spine, so they should be sturdy and attractive.

Materials

Text: 50 sheets of standard-sized paper

Cover: 2 pieces of heavy watercolor, charcoal, or printmaking paper, cut as described below

Ribbon: Cotton crochet tape, strong yarn, soft ribbon, or waxed linen

Hinge pins: 13 thin bamboo skewers, metal rods, pencils, or anything similar

Paste

Tools

Craft knife or mat knife

Ruler

Metal straightedge

Process

1. Cut the cover paper so that each sheet is about 1/4" (6 mm) taller and wider than the text sheets.

2. Fold all of the text paper in half, and create ten signatures, each with five folded sheets. Then cut slices approximately 1" (25 mm) apart down the spine of each signature, making the slits just deep enough to accommodate your hinge pins (Fig. 1). It's possible to use these slits to make the hinges, but threading the sticks through them is extremely difficult. If the slits are widened into wedges (Fig. 2), then threading is much easier.

3. The covers will be slit and wedged in the same manner (Fig. 3), but first they must become double layered. Fold the two pieces of cover paper in half. Paste the halves together, without pasting each one at the spine. The spine must be left open to become the hinge barrel.

4. Fold every other tab back, out of the way, on one signature. Do the same to the opposite tabs on another signature (Fig. 4). When placed close together, they should interlock like the teeth on two gears.

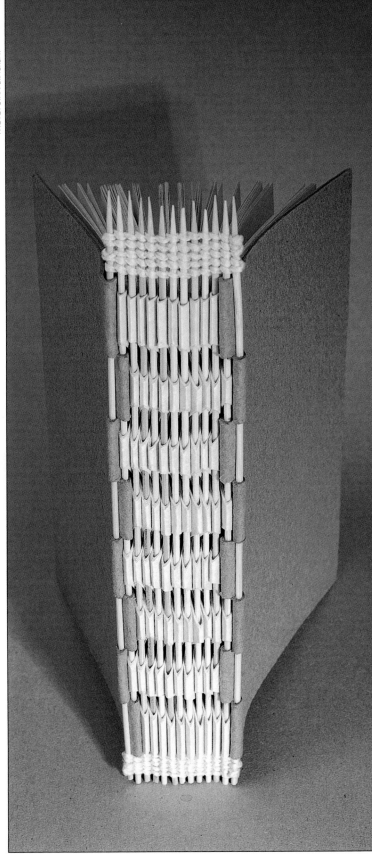

Project model, Shereen LaPlantz.

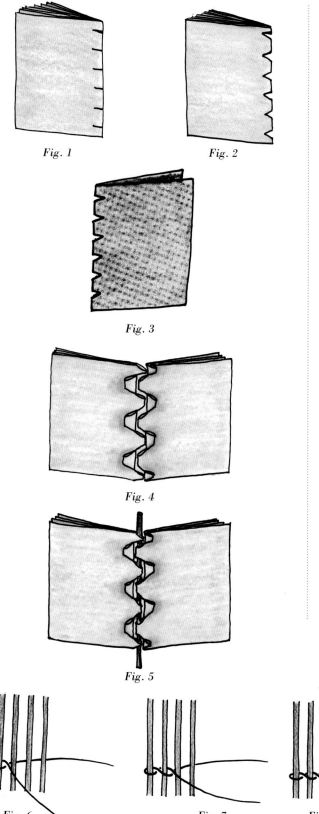

Fig. 1

Fig. 2

Fig. 3

Fig. 4

Fig. 5

5. Thread one of your hinge pins through the interlocking tabs (Fig. 5).

6. Place a third signature next to the two that are already connected, and interlock it the same way. Insert a second hinge pin. Repeat this process until all of the signatures are connected. Then add the covers onto the front and back by threading through their tabs also. There will be an extra, unused set of tabs on each cover that can be dealt with several different ways. They can be left unused, trimmed off, threaded through with another hinge pin, or developed into some other creative solution.

7. To complete the binding, the hinge pins must be held together. Many methods work, and twining was chosen for this project. Twining is simply twisting two strands of thread, yarn, or ribbon around the hinge pins, always traveling in the same direction.

Start by folding the ribbon in half. Loop the fold over the end stick. In an overhand motion, twist the yarn so that the front piece goes behind the adjacent stick and the rear piece goes in front (Fig. 6). Using the same overhand motion, repeat the step (Fig. 7).

8. Repeat until all of the hinge pins have been twined together (Fig. 8). Then turn around and twine the other way. At least two rows of twining are needed to hold the hinge pins in place. Five rows were twined, both top and bottom, for this project.

LIBRARY NEWSPAPER STICKS

In libraries the daily newspapers are held together with long poles. These poles have been sawn into eighths, and each newspaper section slips around one of the eighths. Everything is held in place with rubber O-rings.

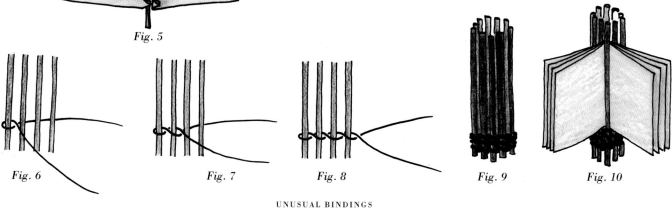

Fig. 6 Fig. 7 Fig. 8 Fig. 9 Fig. 10

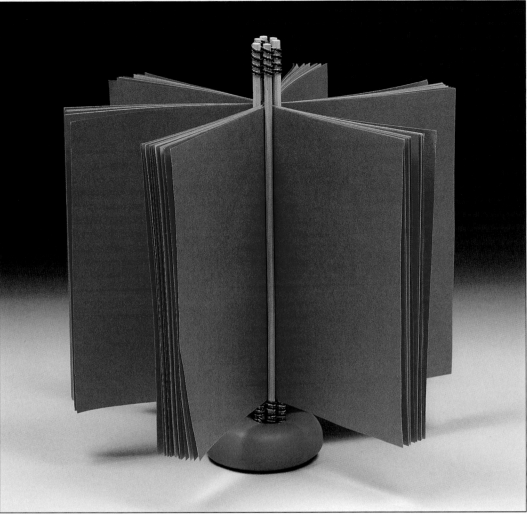

Model, Shereen LaPlantz.

An adaptation of this technique makes an interesting binding for artists' books. Sticks replace the pole, allowing any number of signatures to be used. Since several sticks are used instead of a single pole, more than a pair of O-rings is needed to keep them in place. Once again, twining is an effective technique for holding these together.

Decide how many signatures are desired, and create them. Then select as many bamboo sticks, knitting needles, or metal rods as there are signatures. At the base of the sticks, twine a single row. Then bring the first stick around until it meets the last one, making a circle (Fig. 9). Continue the twining in the same direction. It will automatically spiral up the circle. When the twining is finished, tie off the ends unobtrusively and trim any excess.

Thread each signature onto a stick until all are in place (Fig. 10). Then twine around the top to secure everything. This book will probably need some type of base to hold it upright.

LACED CARDS

Lacing is another fun structure. Rather than being folded into signatures, pages can be laced together in the style of a Venetian blind. This is an ancient technique. In India sanded palm leaves were laced together like Venetian blinds.

When you think of all the things in your home or closet that are laced together, it's easy to realize that there are many possibilities for making interesting bindings. Remember that lacing doesn't have to be done with ribbon or cord; Kathy Crump used metal rods for lacing her book.

One method of lacing uses heavy paper for the pages and threads them onto two ribbons. Make two slits near the top of each page, parallel to the edge of the paper (Fig. 11). The slits should be as long as your ribbon is wide. Thread the ribbons through the slits (Fig. 12) and sew each ribbon in place with a single cross-stitch (Fig. 13). Continue until all of the pages are on the ribbons (Fig. 14).

Paddy Thornbury has turned a Jacob's ladder, a historic child's toy, into a book. This style of lacing goes around the pages rather than through them.

Artist in Progress, Kathy Crump.

Fig. 11

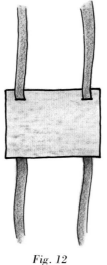

Fig. 12

Jacob's Ladder, Paddy Thornbury.

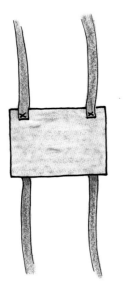

Fig. 13

Fig. 14

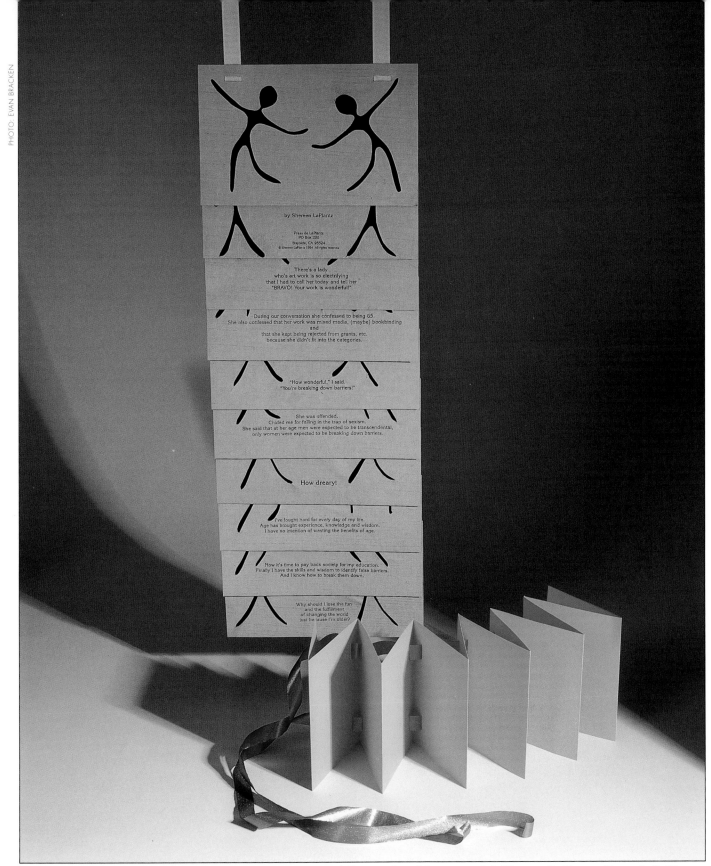

Don't Deny My Fire My Right to Break Barriers! (hanging) and format model, Shereen LaPlantz, Press de LaPlantz.

TAPED BINDINGS

The paper tape used for mounting prints and for book-binding can itself become a binding. It's quite simple: Half the tape goes on one page and half on the facing page, at the spine. This is most effective with thick pages, as is demonstrated by M. Desiree Snider in The *Dream Bug* and Emily Martin in *An Open and Shut Case*.

PASTED BINDINGS

These are as simple as the tape bindings—simply paste the pages together. In her matchbook, Nancy Welch first made an accordion fold, then pasted the pages together at the spine. To finish, she pasted the first and last pages to the inside covers.

Another approach is based on the traditional Japanese butterfly books. First fold each sheet of text paper in half. Then apply paste—on one side only—to a narrow strip along the spine (folded edge) of the first sheet. Stack a second folded sheet on top and press the two together. Repeat until all of the text sheets are pasted together at the spine. The interiors of the folded sheets are open at the fore edge, allowing the pages to fan out when the book is opened.

POST-AND-SCREW BINDINGS

Posts and screws are the devices used in old-fashioned ledgers and in paint sample books. They are available both in metal and plastic at stationery stores. To use them for binding, assemble the text block and covers. Then clamp, mark, and drill holes wherever the posts will be. Be sure that the holes drilled are *not* larger than the posts. The posts are held in place with their matching screws.

EYELET BINDINGS

Eyelet punches and findings are available in larger fabric stores and at stores that carry saddles and horse harnesses. The findings are also called grommets and may be available from leather craft shops. As described above, assemble the text block and covers; then clamp, mark, and drill the holes. To apply the eyelets, follow the instructions that come with the eyelet punch. (Usually the eyelet punch does not suggest pre-punching the holes, but the book block is tougher than a piece of fabric.)

Return of the Spirit, Nancy Welch.

A to Z of Foods, Kathy Crump.

The Dream Bug, M. Desiree Snider.

An Open and Shut Case, Emily Martin.

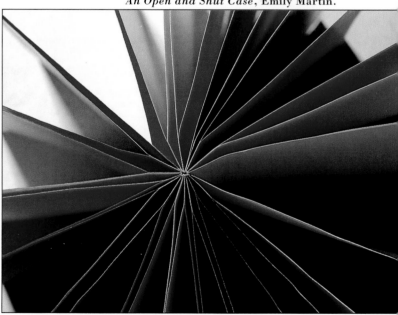

Call for entries, designed by Lisa Buckley and Deirdre Wroblewski, with Wilma Stevens, art director, Joann Seastrom, photographer, and Carma Fazio, manufacturing director. Produced for the Chicago Book Clinic.

Model, Shereen LaPlantz.

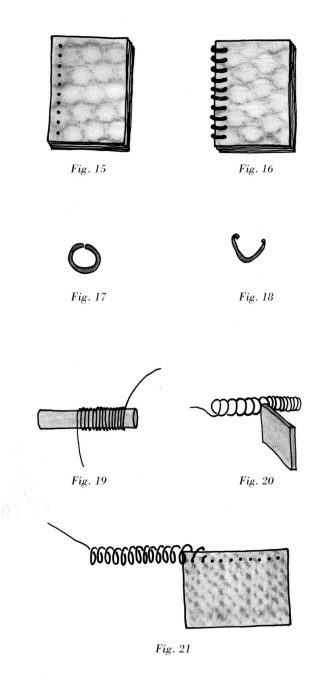

Fig. 15

Fig. 16

Fig. 17

Fig. 18

Fig. 19

Fig. 20

Fig. 21

Fig. 22

RING BINDINGS

Ring bindings are familiar to every schoolchild. In addition to being useful as notebooks, ring bindings are quite functional as artists' books. The rings may be metal, plastic, or whatever is available. Don't forget to check specialty stores for less conventional possibilities. A local livestock supply store, where horse hoof gel and chicken feed are sold, yielded plastic chicken and turkey rings in assorted colors.

To create a ring-bound book, make two separate covers, complete with endpapers. Cut the text papers to size, and place them inside the covers. Mark where you want the holes; then drill through all the layers (Fig. 15). If the rings are metal, open them with two pairs of pliers (Figs. 16 and 17). Insert each ring through a hole (Fig. 18) and squeeze the two open ends of the ring together by closing the jaws of one pair of pliers.

Metal presents itself as a good potential material for text pages having ring and spiral bindings. Metal can be combined with paper to make pages, or it can be used alone for pages. It can be stamped, embossed, engraved, or etched to create text and images. It's also possible to print on metal. Check with local sports centers and trophy shops to find one that prints images on metal (usually aluminum).

SPIRAL BINDINGS

There are two types of spiral binding: the commercial-style wire spiral, which has specific measurements and rules, and the inventive kind, where the measurements are adjusted to whatever is desired. The commercial style is discussed here because it might be helpful to know the rules first, then make new ones.

Start as you did for a ring binding, with two separate covers and a text block. The size of the holes drilled depends on the gauge of the wire chosen for your spiral, and the spacing depends on the hole size. With wire that is 16- to 20-gauge, the holes should have a 1/8" (3 mm) diameter and should be spaced 1/4" (6 mm) apart. For wire that is 13- to 20-gauge, use 3/16" (5 mm) holes spaced 5/16" (8 mm) apart.

After deciding on the measurements, mark and drill the holes. Place the holes 1/4" (6 mm) in from the spine.

Before it can be used for the binding, the wire must be coiled. The diameter of the coil varies according to the thickness of the text block and covers. A book 1/4" (6 mm) thick should have a coil with a 1/2" (13 mm)

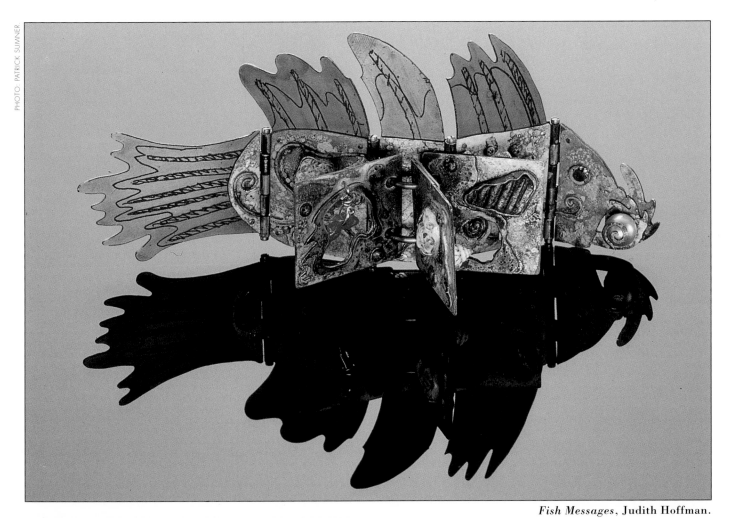

Fish Messages, Judith Hoffman.

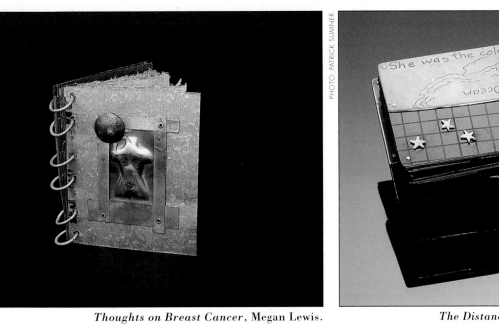

Thoughts on Breast Cancer, Megan Lewis.

The Distance of the Moon, Judith Hoffman.

diameter. One that is between 1/4" and 1/2" requires a coil whose diameter is 1.75 times the book's thickness. If your book is 1/2" or more, the coil should be 1.5 times the thickness of the book.

Once the diameter of the coil is decided, the coil has to be made. Find a metal rod the correct size and wrap the wire around it in a tight spiral (Fig. 19).

To thread easily into the holes in the book, the coil should be spread apart beforehand. Start by slipping a thin piece of cardboard in between the wires and spiraling it around the coil easily (Fig. 20). Keep making passes through the coil with thicker and thicker pieces of cardboard. Continue doing this until the coil is properly spaced to fit the holes in the book.

Starting at one end of the book, thread the wire coil through the holes (Fig. 21). If the coil has been spaced properly, this should be quite easy. If the spacing isn't correct, the wire will have to be spread while threading. This will be difficult, and the wire may even gouge the book.

When the threading is done, trim off any excess wire. Then bend the two ends sharply inward to hold them in place (Fig. 22).

Spiral bindings can be made from any stiff, yet slightly flexible, long material. Plastic tubing, wire cables, plastic-covered wire, or twisted paper cord will all work. The local hardware store is full of interesting materials for this type of binding.

Something as bulky as plastic tubing won't fit any of the above measurements. Consequently there's a need to improvise. Develop ratios that look pleasing, keeping in mind that the holes shouldn't be too close to the edge or so close together that they cause weakness. Do include enough holes to allow ease in opening.

OTHER TECHNIQUES

Closely related to spiral bindings are comb bindings. These are plastic strips containing several "teeth" that curve through rectangular holes in a book. Because the teeth are connected to the spine at just one side, a comb binding is easier to remove than a ring or spiral binding, should you wish to add a page to your book after the fact. This type of binding can be done at most print and copy shops. If you plan to use this process extensively, you may wish to buy a comb binding machine.

Emil's Garden, Edward H. Hutchins.

True Light, Judith Hoffman.

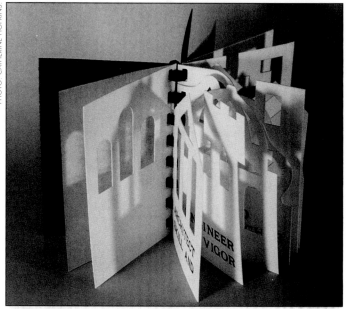

Buildings, Edward H. Hutchins.

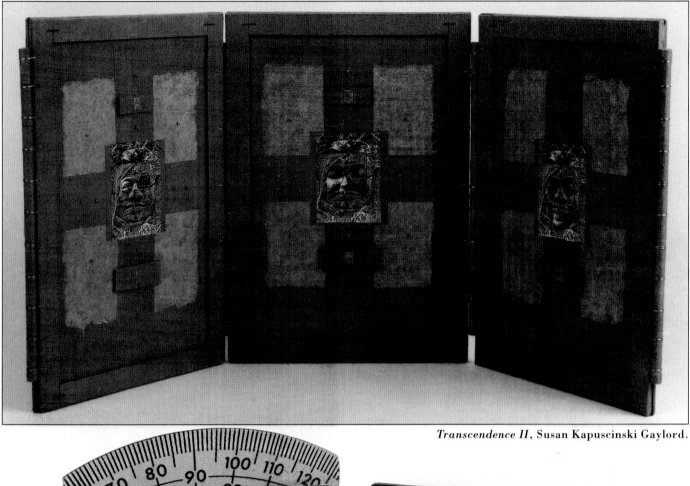

Transcendence II, Susan Kapuscinski Gaylord.

Instruction Manual for the Moon, Judith Hoffman.

Staples also provide a quick and easy binding. In *Artist's Book #1*, David LaPlantz used staples to attach the signature to a metal backing. Although an office-size stapler could work, he used the oversized staples from a staple gun. He drilled holes in both the paper and the metal, then inserted the staples and bent them into place by hand. This eliminated any chance of dimpling the paper with too much mechanical pressure.

Premade metal hinges from the hardware store make another simple but effective binding. Lynn A. Mettes-Ruggiero in *The Doorbell Is Ringing* and Deborah Nore in *It All Depends on How She Plays Her Cards* have both used premade metal hinges.

This chapter orients itself more toward different techniques than different formats; therefore, here are a few more possibilities. One is actually a stab binding using safety pins. Another is similar to a string of beads, except that every other bead is a signature. This technique is probably best with broadsides (single sheets) than with signatures. Finally, a box folded in the style of a Japanese coin purse has signatures sewn into the folds.

Artist's Book #1, David LaPlantz.

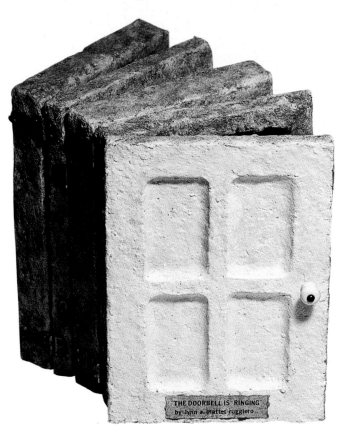

The Doorbell Is Ringing, Lynn A. Mattes-Ruggiero.

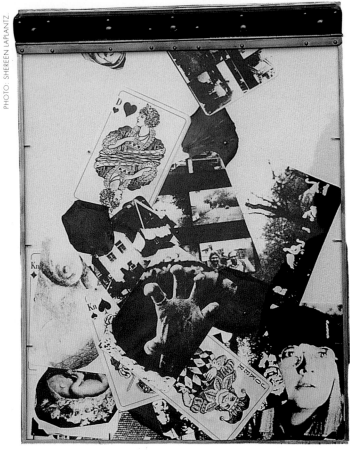

It All Depends on How She Plays Her Cards, Deborah Nore.

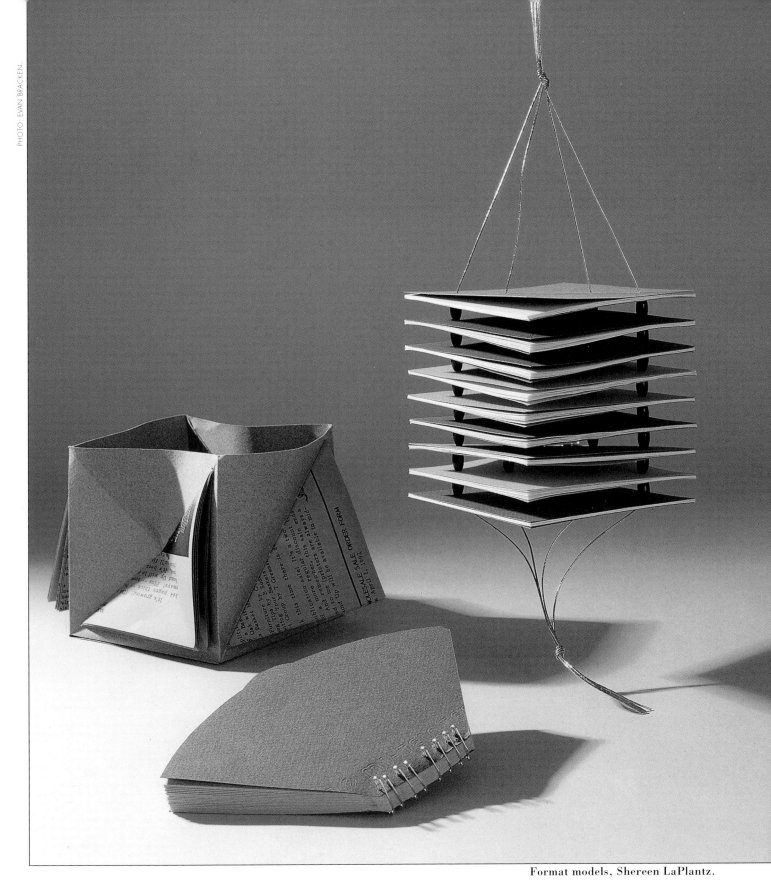

Format models, Shereen LaPlantz.

PRESENTATION COUNTS

HOW A PIECE IS PRESENTED usually determines how well it is received. No one would go to a job interview looking sloppy—that would be a bad presentation (and one with a predictable outcome). Similarly, whether your book is an art piece for sale, an assembly of the family archives, or a quick greeting to a friend, its presentation should be worthy of your creative efforts.

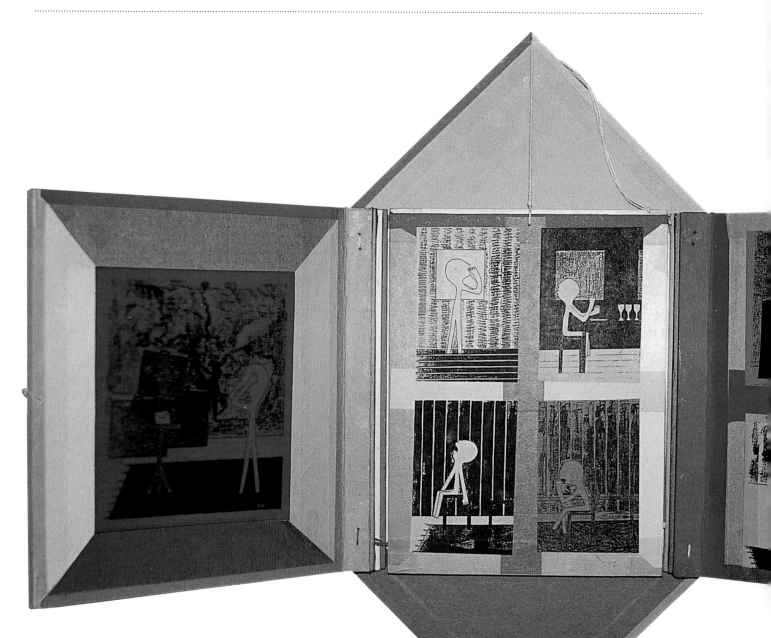

Making a Long Story Short, Emily Martin.

Making a Short Story Long, Emily Martin.

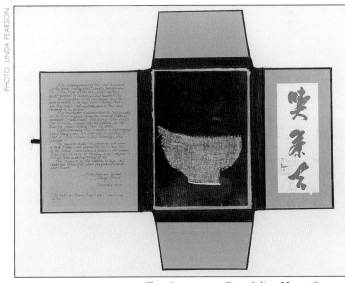

Tea Ceremony Portfolio, Mary Street.

Generally book presentations have two styles: single impression and reader involvement. The former is a "no holds barred" philosophy that reveals much about the book at first glance. The latter is more of a discovery process; it engages the reader to unfold the book's secrets.

Once opened, Emily Martin's pieces have a powerful impact, almost a stage presence, without any further involvement from the reader. Bonnie Stahlecker's *Barriers Within, Barriers Without* takes a different approach but has a similar powerful impact. No less intense is Mary Street's *Tea Ceremony Portfolio*, which projects a strong intimate feeling.

In *Lunch!* Edward H. Hutchins creates a strong visual impact through numbers. These whimsical frogs are small, and one might get overlooked if it were on its own. As a group they create the desired effect.

Other book presentations contain many possible levels of involvement for the reader. Simple involvement may require the reader to open a box or remove the book from a slipcover. The reader becomes more involved when asked to open a box that is not clearly a book or when required to remove pages from a book to expose a hidden treasure.

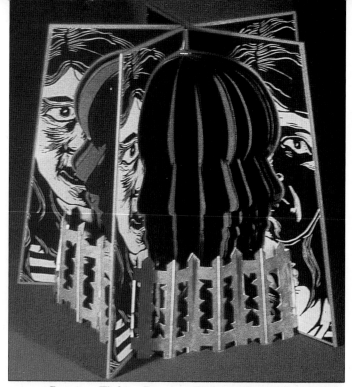

Barriers Within, Barriers Without, Bonnie Stahlecker.

Book Box: Elvis or Marilyn, Mary Todd Shaw.

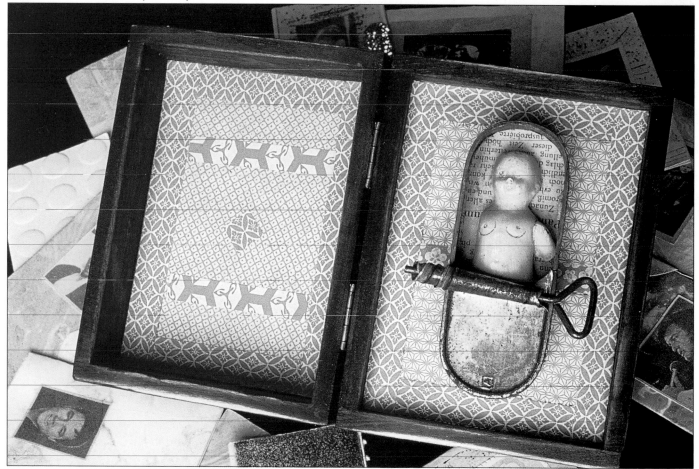

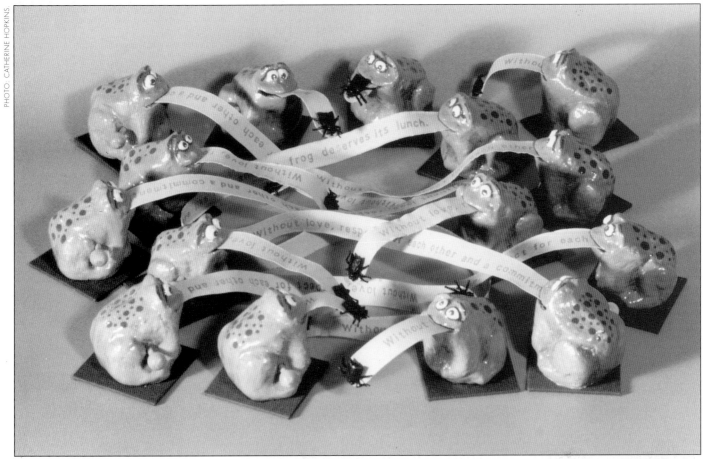

Lunch!, Edward H. Hutchins.

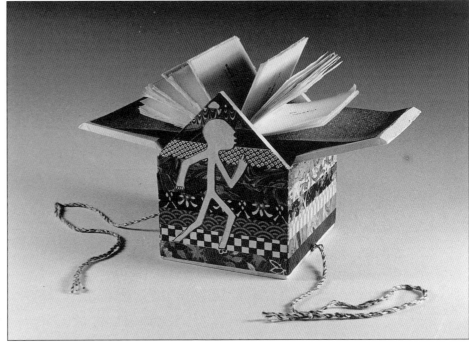

Oh, the Things You'll Say.
A Mother at Home,
Emily Martin.

Through the involvement of the reader, the process of reading the book may become almost ceremonial. In other works, this involvement is fun and whimsical.

The presentation may even overpower the contents of the book. In these instances, the presentation itself becomes the work of art, which is enhanced by the text, rather than the other way around. This style of presentation usually has the strongest visual impact.

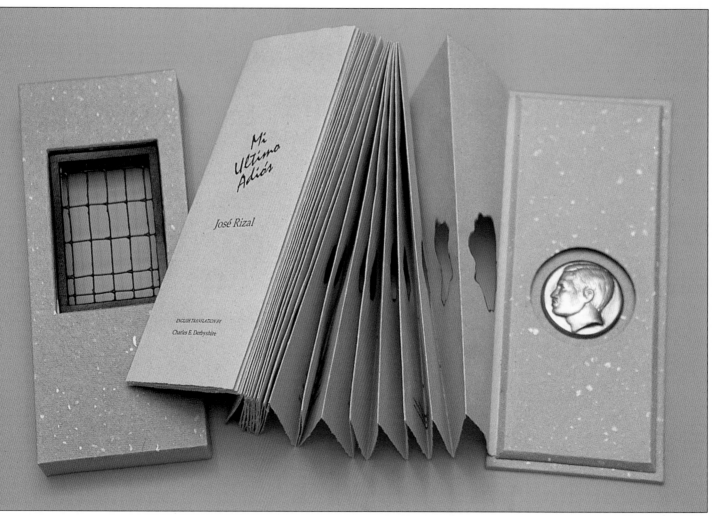

Mi Ultimo Adios, Gabriel A. Ella, with poetry by Jose Rizal.

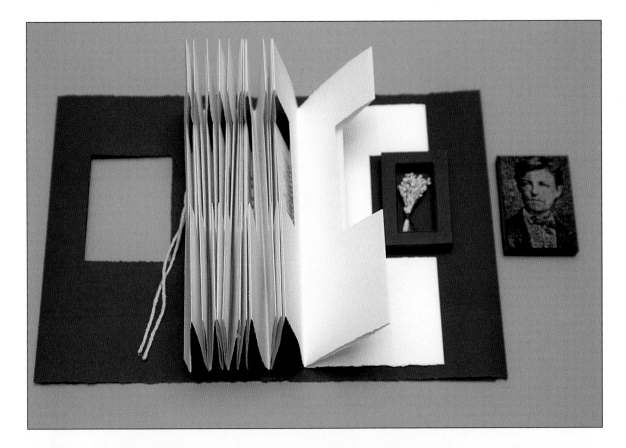

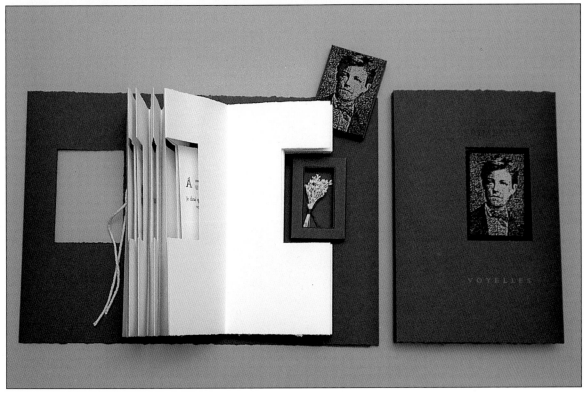

Photos this page:
Voyelles, Gabriel
A. Ella, with
poetry by
Arthur Rimbaud.

Ancient Parasol Reading Test, Alisa Golden.

Whatta Pie, Edward H. Hutchins.

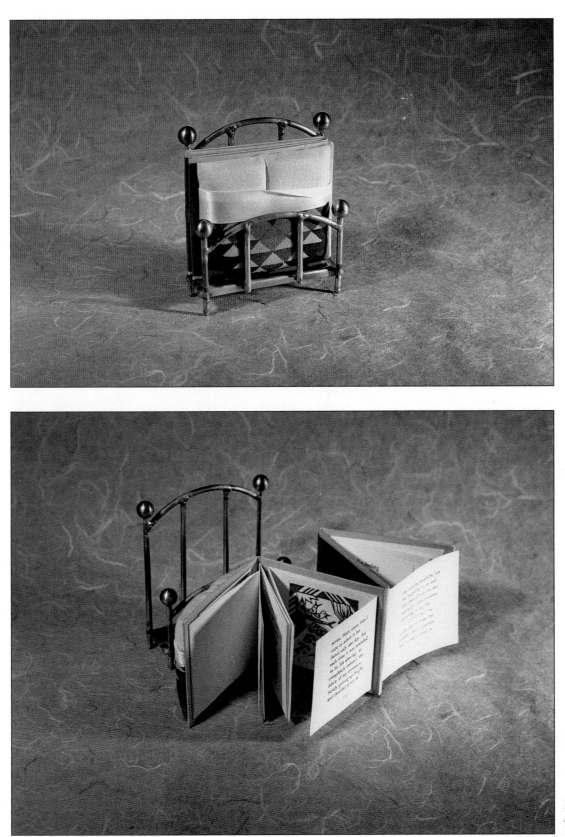

Photos this page: *Sleep Achiever*, Pat Baldwin, Pequeño Press.

One last thought on the subject of presentation: Books are usually created in editions. However, there is no law demanding that each copy of an edition be the same. Peter Sramek has the most unusual approach to presentation—he keeps changing it. Four copies of his *In Search of Paradise - Night Vision* look like four entirely different books because of the changes he made in format and presentation.

As you're looking at the possibilities shown here and imagining presentations for your own books, visualize these books without the strong presentation they have. If they were simple codices with plain covers, would they be as interesting? Would you be as inclined to open them and read? A lot of effort is required to design and create both the structure and the text for a book; make sure yours is inviting.

Photos this page:
In Search of Paradise - Night Vision, Peter Sramek.

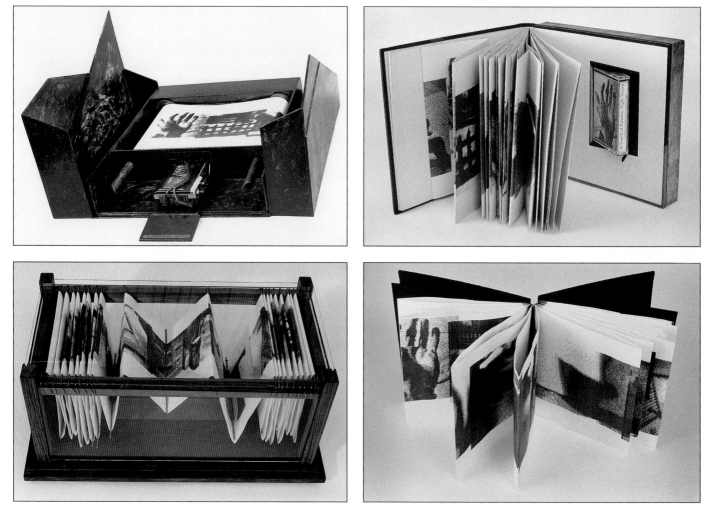

Above and left:
Prayer Tower,
Jenny Hunter Groat.

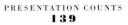

Bookbinding Suppliers and Sources of Information

GENERAL SOURCES

Archival supply houses usually carry some bookbinding tools and some acid-free papers and boards. General art supply houses carry papers and boards, along with some tools and equipment.

American Printing Equipment and Supply Company
42-25 Ninth Street
Long Island City, NY 11101
718-784-7010
printing & bookbinding equipment

Amsterdam Art
1013 University Avenue
Berkeley, CA 94710
510-649-4800
general art supplies & tools, plus papers

Basic Crafts
1201 Broadway
New York, NY 10001
212-679-3516
bookbinding supplies, tools & equipment

Benchmark
P.O. Box 214
Rosemont, NJ 08556
609-391-1159
primarily mounting supplies

The Bookbinder's Warehouse Inc.
31 Division Street
Keyport, NJ 07735
908-264-0306

Bookmakers
6001 66th Avenue, Suite 101
Riverdale, MD 20737
301-459-3384
bookbinding supplies, tools & equipment

Brodhead Garrett
223 South Illinois Avenue
P.O. Box 8102
Mansfield, OH 44901-8102
419-589-8222
general art supplies, tools & equipment

Carr McLean
461 Horner Avenue
Toronto, Ont, Canada M8W 4X2
416-252-3371
archival supplies

Colophon Book Arts Supply Inc.
3046 Hogum Bay Road NE
Olympia, WA 98516
206-459-2940

The Davey Company
164 Laidlaw Avenue
Jersey City, NJ 07306
201-653-0606
Davey board

Gane Brothers & Lane, Inc.
corporate headquarters, 1400 Greenleaf Avenue
Elk Grove Village, Il 60007
800-323-0596
bookbinding supplies, tools & equipment

Gaylord Brothers
P.O. Box 4901
Syracuse, NY 13221-4901
800-448-6160
archival help line: 800-428-3631
archival supplies, bookbinding supplies, tools & equipment

The Harcourt Bindery
51 Melcher Street
Boston, MA 02210
617-542-5858
bookbinding supplies & tools

Johnson Bookbinding Supply Company
32 Trimountain Avenue
P.O. Box 280
South Range, MI 49963
906-487-9522
printing and bookbinding supplies, tools & equipment

Light Impressions
439 Monroe Avenue
P.O. Box 940
Rochester, NY 14603-0940
800-828-6216
archival supplies

Daniel Smith
4150 First Avenue South
P.O. Box 84268
Seattle, WA 98124-5568
800-426-6740
general art supplies & tools, some bookbinding supplies, plus papers

Talas
213 West 35th Street
New York, NY 10001-1996
212-736-7744
bookbinding supplies, tools & equipment, also archival supplies

University Products, Inc.
517 Main Street
P.O. Box 101
Holyoke, MA 01041-0101
800-628-1912
archival supplies, including book repair supplies, tools & equipment

Tip: The *Thomas Register*, found in most libraries, is an encyclopedic listing of what's available and who manufactures it within the U.S. When something is hard to find, the Thomas Register often has a listing for it.

PAPERS

Many of these places also make custom papers and/or give workshops and lectures in papermaking, letterpress, etc.

Aiko's Art Materials Import, Inc.
3347 North Clark Street
Chicago, IL 60657
312-404-5600
Japanese papers & art supplies

Carriage House Paper
P.O. Box 197
North Hatfield, MA 01066
800-669-8781
handmade papers, etc.

Dieu Donne Papermill Inc.
3 Crosby Street, 5th floor
New York, NY 10013
212-226-0573
specialty papers

McManus & Morgan Inc.
2506 West Seventh Street
Los Angeles, CA 90057
213-387-4433
general & specialty papers, etc.

Paper-Ya & Kakali Handmade Papers Inc.
9-1666 Jonston Street
Granville Island
Vancouver, BC, Canada V6H 3S2
604-684-2531
specialty papers

Twinrocker Handmade Paper
P.O. Box 413
Brookston, IN 47923
800-757-TWIN
handmade papers, etc.

BOOK ARTS CENTERS

These organizations offer workshops and exhibitions on book arts/bookbinding. They often send out newsletters and class listings, offer member's benefits, and sometimes have studio space available.

Book Arts & Letterpress Studio
Armory Center for the Arts
145 N Raymond Avenue
Pasadena, CA 91103
818-792-5101

Center for the Book
University of Iowa
102 EPB
University of Iowa
Iowa City, IA 52240
319-335-0438

Center for Book Arts
626 Broadway, 5th floor
New York, NY 10012
212-460-9768

Chicago Book Clinic
11 South LaSalle Street, Suite 1400
Chicago, IL 60603
312-553-2200

Minnesota Center for Book Arts
24 North Third Street
Minneapolis, MN 55401
612-338-3634

Pacific Center for the Book Arts
P.O. Box 424431
San Francisco, CA 94142+4431

Pyramid Atlantic
6601 66th Avenue, Suite 103
Riverdale, MD 20737
301-459-7154

Women's Studio Workshop
P.O. Box 489
Rosendale, NY 12472
914-658-9133

NEWSLETTERS

The Abbey Newsletter
7105 Geneva Drive
Austin, TX 78723
512-929-3992
bookbinding and conservation

Alliance for Contemporary Book Arts (Ampersand)
P.O. Box 24415
Los Angeles, CA 90024
818-906-9971
book arts

Book Arts Classified
Page Two, Inc.
2718 SW Kelly, Suite 222
Portland, OR 97201
800-821-6604

Bookways
1906 Miriam Avenue
Austin, TX 78722-1714
512-478-7414
contemporary book arts, quarterly

The Movable Book Society
P.O. Box 11654
New Brunswick, NJ 08906
pop-up and mechanical book artists and collectors

Umbrella
P.O. Box 40100
Pasadena, CA 91114
310-399-1146
artists' books

GUILDS

There are quite a few local book arts guilds. Check with your local arts organizations to find one near you. There are two guilds worth noting specially; both are national in scope, and both have informational newsletters.

The Canadian Bookbinders and Book Artists Guild
35 McCaul Street, Suite 220
Toronto, Ontario, Canada M5T 1V7

Guild of BookWorkers
521 Fifth Avenue
New York, NY 10175

CONTRIBUTING ARTISTS

Kathleen Amt
Pat Baldwin
Carol Barton
Elaine S. Benjamin
JoAnne Berke
Nancy Callahan
Julie Chen
Kathy Crump
Denise DeMarie
Judy Dominic
Gabriel A. Ella
Elsi Vassdal Ellis
Susan Kapuscinski Gaylord
Alisa Golden
Jenny Hunter Groat
Dolores Guffey
Barbara Heisler
Carol Pallesen Hicks
Judith Hoffman
Edward H. Hutchins
Lois James
Tom Jones
David LaPlantz
Megan Lewis
Mary Ellen Long
Emily Martin
Lynn A. Mattes-Ruggiero
Nancy McIntosh
Deborah Nore
Claire Owen
Robin Renshaw
Mary Todd Shaw
Genie Shenk
M. Desiree Snider
Peter Sramek
Bonnie Stahlecker
Mary Street
Dorothy Swendeman
Aliza Thomas
Paddy Thornbury
Ginny Dewey Volle
Nancy Welch
Lin Westra

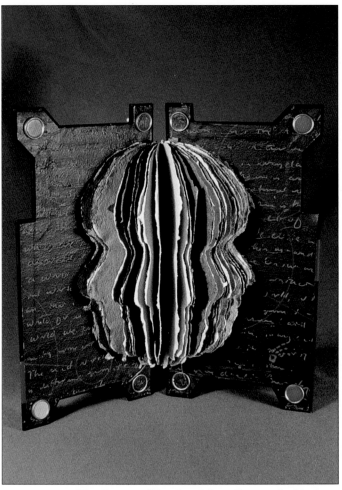

The Range of Predictability, Bonnie Stahlecker.

ACKNOWLEDGMENTS

Special thanks go to the local book artists who rallied around this book, almost making it a group project. They have shared ideas, techniques, and enthusiasm. And when it appeared there might be some techniques lacking, they came together for a bookbinding party, spending a whole day making examples to fill the holes. Thank you, Elaine Benjamin, JoAnne Berke, Dolores Guffey, Barbara Heisler, Robin Renshaw, and Dorothy Swendeman.

BIBLIOGRAPHY

Banister, Manly. *The Craft of Bookbinding*. New York: Dover, 1975.

Brown, Margaret R. *Boxes for the Protection of Rare Books: Their Design & Construction*. Washington: Library of Congress, 1982.

Cockerell, Douglas. *Bookbinding and the Care of Books*. New York: Lyons & Burford, 1901 and 1991.

Diehl, Edith. *Bookbinding: It's Background and Technique*. Two volumes bound as one. New York: Dover, 1980.

Ekiguchi, Kunio. *Gift Wrapping*. Tokyo: Kodansha International, 1985.

Foot, Mirjam M. *Studies in the History of Bookbinding*. Hants, England: Scolar, 1993.

Greenfield, Jane, and Hille, Jenny. *Headbands: How to Work Them*. New Castle, Delaware: Oak Knoll, 1990.

Ikegami, Kojiro. *Japanese Bookbinding*. New York: Weatherhill, 1979.

Johnson, Arthur W. *Book Repair and Conservation*. London: Thames and Hudson, 1988.

————. *The Practical Guide to Craft Bookbinding*. London: Thames and Hudson, 1985.

————. *The Thames and Hudson Manual of Bookbinding*. London: Thames and Hudson, 1978.

Johnson, Paul. *Literacy through the Book Arts*. New Hampshire: Heinemann, 1993.

Johnson, Pauline. *Creative Bookbinding*. New York: Dover, 1963.

Kafka, Francis J. *How to Clothbind a Paperback Book*. New York: Dover, 1980.

Kitagawa, Yoshiko. *Creative Cards*. Tokyo: Kodansha International, 1987.

Kondo, Yoko. *Creative Gift Packaging*. Tokyo: Ondorisha, 1986.

Kyle, Hedi. *Library Materials Preservation Manual*. New York: Nicholas T. Smith, 1983.

Lewis, A. W. *Basic Bookbinding*. New York: Dover, 1957.

Mitchell, John. *A Craftsman's Guide to Edge Decoration*. West Sussex, England: Standing Press, 1993.

Olmert, Michael. *The Smithsonian Book of Books*. Washington: Smithsonian Books, 1992.

Smith, Keith A. *Non-Adhesive Binding*. Fairport, New York: Sigma Foundation, 1990.

————. *Structure of the Visual Book*. New York: Keith A. Smith, 1984.

Watson, Aldren A. *Hand Bookbinding: A Manual of Instruction*. New York: Bell, 1963.

Zeier, Franz. *Books, Boxes and Portfolios*. New York: Design Press, 1990.

INDEX